GYPSET
TRAVEL

Text © Julia Chaplin
Illustrations © Kate Schelter
© 2012 Assouline Publishing
601 West 26th Street, 18th Floor
New York, NY 10001, USA
www.assouline.com
ISBN: 9781614280620
Color separation by William Charles Printing
Printed in Turkey

JULIA CHAPLIN

GYPSET
TRAVEL

ASSOULINE

CONTENTS

INTRODUCTION 8

MONTAUK, *USA* 14

WEST COUNTRY, *England* 34

DEIÀ, *Spain* 50

AEOLIAN ISLANDS, *Italy* 64

LAMU, *Kenya* 78

NORTH GOA, *India* 90

BYRON BAY, *Australia* 104

JOSÉ IGNACIO/CABO POLONIO, *Uruguay* 118

ALTO PARAÍSO, *Brazil* 134

TODOS SANTOS, *Mexico* 150

ADDRESS DIRECTORY 164

ACKNOWLEDGMENTS
& PHOTO CREDITS 168

Following pages: Watercolor of the gypset atlas by Kate Schelter.

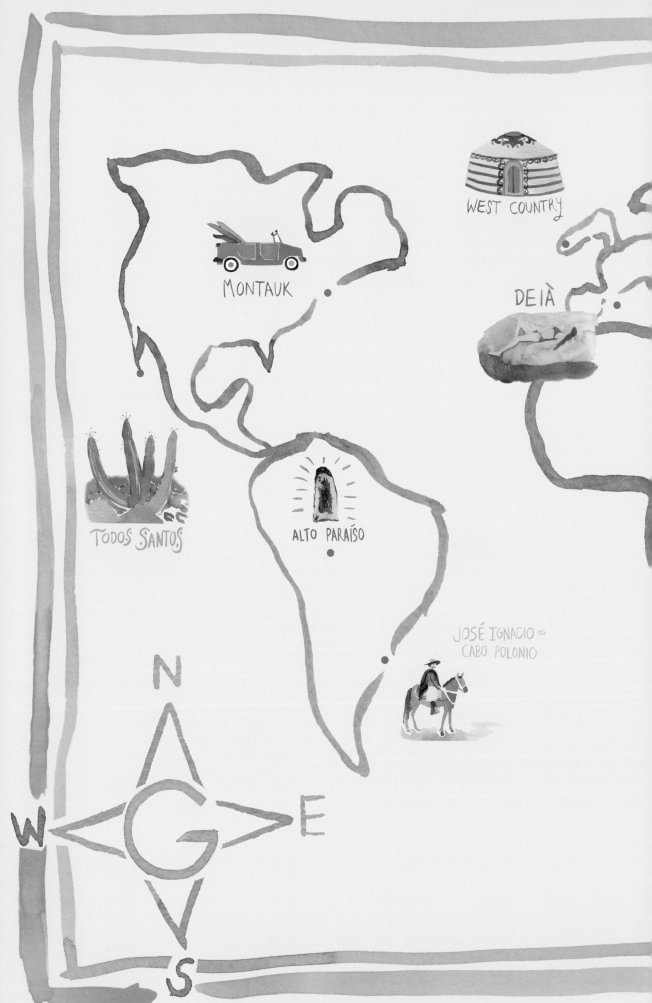

MONTAUK

WEST COUNTRY

DEIÀ

TODOS SANTOS

ALTO PARAÍSO

JOSÉ IGNACIO &
CABO POLONIO

N

W G E

S

AEOLIAN ISLANDS

NORTH GOA

LAMU

BYRON BAY

Gypset Atlas

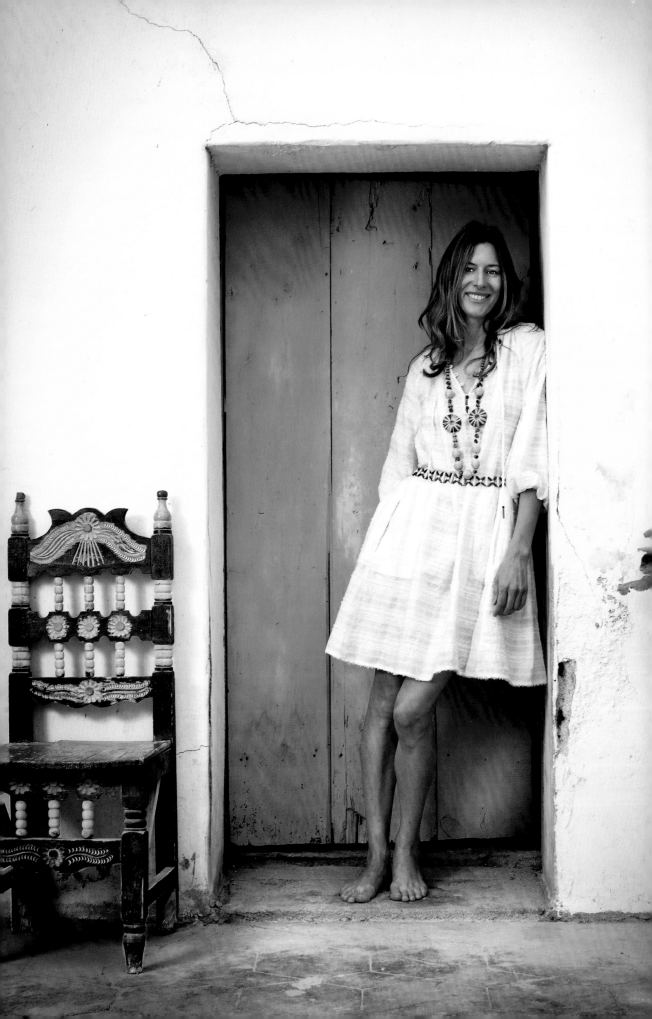

INTRODUCTION

gypset *n. An unconventional, bohemian approach to life. —adj. Characterized by a fashionable exoticism and down-to-earth ease.* —gypsetter *n. One who is gypset. (A portmanteau word: the wiles of a gypsy mixed with the sophistication of the jet set.)*

The gypset atlas doesn't look like a normal map. Instead of metropolises like London, Shanghai, and Moscow, the capitals of our world are small, out-of-the-way towns like Filicudi, Italy; Cabo Polonio, Uruguay; and Deià, Spain. Gypset enclaves are wildly different and stubbornly individual, but they tend to share a few key qualities. Being near the equator is a plus (and a bohemian legacy), not to mention a good surf break. Although there are only ten locations profiled in this book, there are dozens more and new ones popping up all the time. My hope is that as the gypset world grows, there will be less need to spend time in the old one.

Since my last book, *Gypset Style* (2009), there's been a collective rethinking of luxury and values, perhaps as a result of the economic crises of the last few years. Whatever the reason, the gypsetter's lifestyle—which is based more on creativity than cash—seems to be catching on. *Gypset Style* examined the history of the movement. The book you hold in your hands now is about the places where gypset culture has taken root.

I had one basic criteria guiding my selection of the destinations spread out over the following pages. Each locale had to have new ideas. In other words, these are not the same old hippie haunts, clinging to the past. They had to be animated by new energy and a high level of experimentation: the crazier the concepts, the better. There were many places I wanted to include but that simply didn't fit into a limited amount of pages—or, more often, I just couldn't get there in time. My research took several years as I hopscotched across continents and countries—from Africa to India, Mexico, and points beyond—following tips I received along the way.

The author at Castilla de Dracula in Todos Santos, Mexico, January 2012.

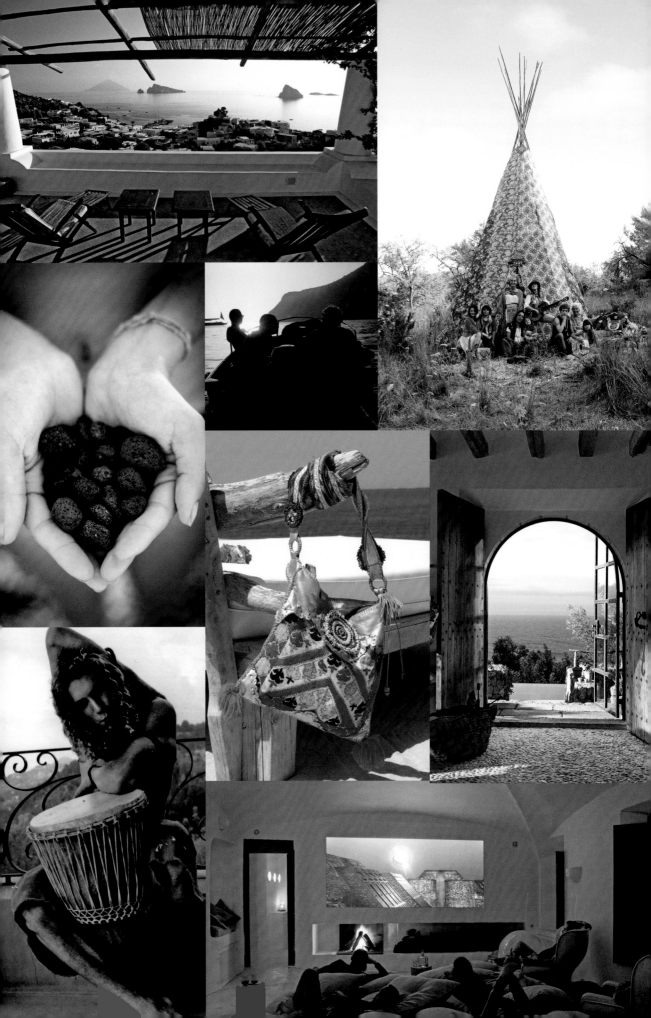

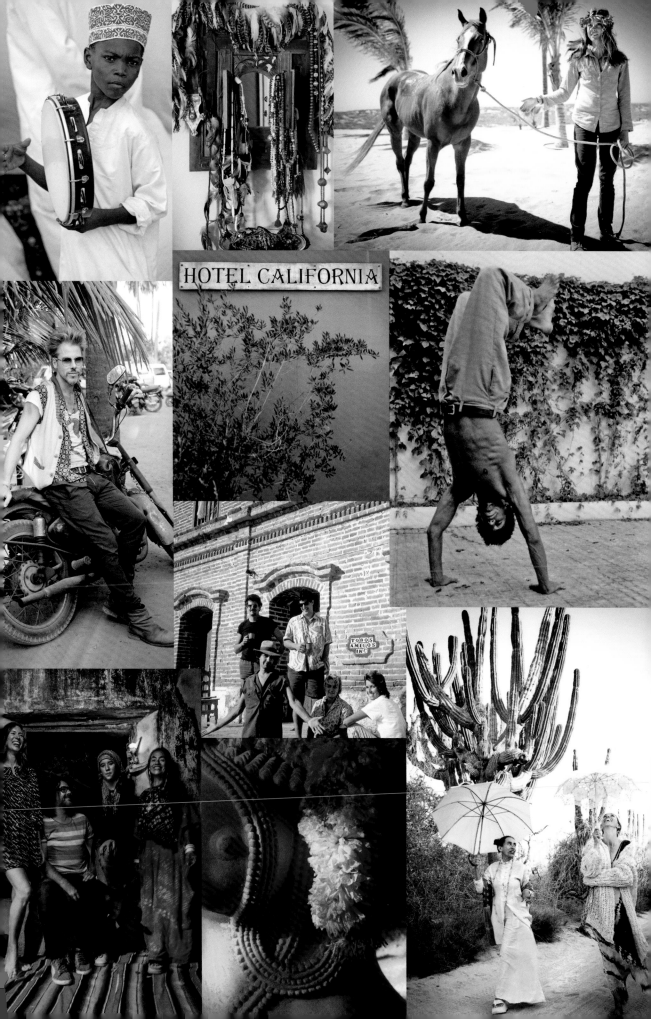

HOTEL CALIFORNIA

If you haven't read the first book, here's the short version: Gypset dates back in history to artists, thinkers, and bon vivants who stepped out of society—literally. It started at least as far back as Lord Byron and the British Romantic poets; Victorian-era explorers including Sir Richard Burton and Jane Digby; the surrealists in Mexico; and the beatniks in 1950s/'60s Tangier like Paul Bowles and William Burroughs. The rise of commercial air travel enabled the '60s jet set, but it's when that group collided with the hippie backpackers that things became a lot more interesting. Suddenly, you had newly minted rock stars blowing off the swells in Acapulco or Palm Beach, and jetting to meditation ashrams in India. Ethnic styles found in souks and street stalls were transformed for the runways by designers like Yves Saint Laurent, Giorgio di Sant' Angelo, and Ossie Clark. It girls like Veruschka and Talitha Getty endorsed the new high-low social order by living it.

By the late 1990s the jet set had devolved into a big, boring, corporate-sponsored party. Instead of complaining, the nascent gypset did something about it: They rerouted and searched the globe for inspiring new places where they could create and think. The goal wasn't to regress, sixties-style, into longhaired dropouts: The gypset were more organized and engaged than that. They wanted to contribute to society—but they wanted to do it on their own terms. And thanks to the Internet, the rise of a freelance workforce, and the ease of subletting, they could.

Another thing that has changed since the publication of *Gypset Style* is that some jet-setters are crossing over to our side. José Ignacio, Uruguay, is a coveted resort town on the same moneyed circuit as Capri and East Hampton, but its most popular hangouts are rustic shacks on the sides of dirt roads with bonfires burning in the sand. In Goa, India, wealthy Bollywood stars and playboy types are commuting north from their plush resorts to hang out in Ashvem, a laid-back beach community populated by nudists and yogis.

I like to think of this book, *Gypset Travel,* in terms of the rich history of social migrations—which have always been telling barometers of change. In the seventeenth and eighteenth centuries, the Grand Tour was popular. Fashionable young men and women traveled abroad—to Geneva, Venice, and Rome—to experience high culture and higher society. Charles Dickens wrote a scathing satire of the elitist rite of passage in his serial book, *Little Dorrit* (1857).

In the 1960s and '70s there was the Hippie Trail: a mass spiritual quest that stretched from Europe and wound east through Tehran, Kabul, Peshawar, and into India and, at its farthest reach, on to Southeast Asia. Kathmandu still has a road nicknamed "Freak Street" in memory of the many thousands who passed through.

The Banana Pancake Trail is the name that was given to the post collegiate backpacker hubs scattered around Southeast Asia. (Think of Ko Pha Ngan, the Thai island featured in Alex Garland's

Page 10: Life in the gypstream: scenes from Filicudi, Ibiza, Todos Santos, Ashvem, and on and on.

1996 novel, *The Beach*). In the 1990s hordes of Teva-clad revelers went searching for patches of empty white sand and full moon parties. Banana pancakes are typically served for breakfast in the hostels that cater to them. Transport was by discount airlines so the concept of a "trail" is really more of a metaphor.

Gypsetters too have a specific migratory path. The stops on the gypset circuit are not unified by geography but rather, by a feeling. Every gypset community is rooted in a common goal, a redefining of rules and mores. Before beginning this book, I assumed that utopias didn't really exist, but I have come to believe that, on a personal scale, they can. Either way, it's the effort and commitment that's interesting, whether it's experimental architecture or an approach to life. In Alto Paraíso, Brazil, I found a small mountain town overgrown by weeds and brush, newly colonized by a group of people testing out ayahuasca and permaculture. In Cabo Polonio, Uruguay, I hung out in a squatters' community that had turned off-the-grid living into something beautiful and stylish. In other cases—towns including Todos Santos, Mexico, Byron Bay, Australia, and Montauk, New York—the utopia was more internal. It was about finding a spot somewhat isolated from the clamor, where one could be inspired with a group of friends.

The more far-flung the gypset pin on the map, the clearer it was how connected they all were. Social coincidences—like ancient aboriginal songlines—turned out to be the migratory path itself. For example, Brian Hodges, the photographer of the Todos Santos chapter, had spent a summer in the Aeolian Islands sailing with the Guillaumes—a French family who live on their boat but winter in Lamu, Kenya. And last January the Guillaumes (Pierre, Eve, and their daughters, Olympe and Lulu) were in Lamu staying at the house of Roberta and Chris Hanley, filmmakers from Los Angeles. But when I was having lunch in José Ignacio, Uruguay, I discovered that the Hanleys, whom I had never met, happened to be sitting on the bench next me. I also met a Venezuelan there who had spent time in Deià, a village on the island of Majorca, Spain. He introduced me to the gypset community there, including a young man named Balthazar Klarwein, whose stepmother happens to be Caterine Milinaire—the beautiful English journalist and photographer who graced the cover of *Gypset Style*. These types of dense interconnections kept popping up throughout my journey. It was a sign that I was on the right invisible track.

When I finished my travels and came back to my home in New York City to write this book, I was constantly reminded of a game called "sardines" that I loved to play as a child—and sometimes now. It's a variation on hide-and-seek. The person who's "it" hides and then the group splits up and goes searching. But when you find the "it" person, instead of calling out to the others, you quietly squeeze in and hide with them.

Page 11: By definition gypset enclaves are hard to find, hard to reach, and with any luck, near a good surf break.

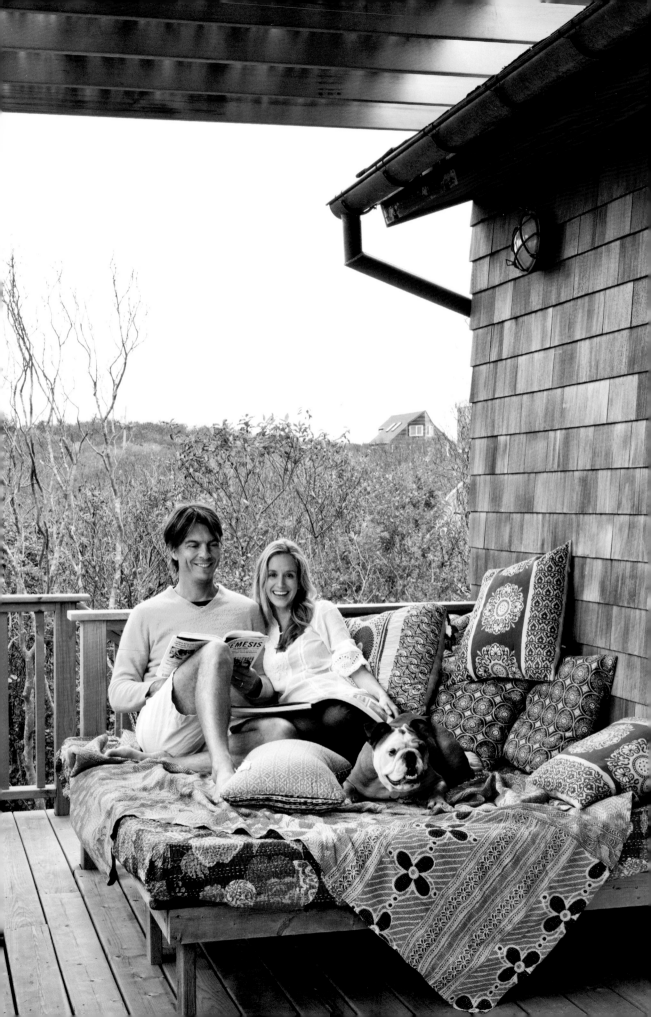

MONTAUK

"I own a house in Montauk but I never go there except as a guest.
Actually I hope I'm never invited. I dread going there. I hate the sun. I hate the sea."
ANDY WARHOL, *Exposures*

Andy Warhol bought a compound of five cottages in Montauk on an exposed, windswept bluff overlooking the Atlantic Ocean in the 1970s, mainly because it was cheap. He named it Eothen (a Greek word meaning "toward the east"). He would have preferred a grand house in Southampton—it was much closer to Manhattan and had more socialites to lunch with. But as it turned out, Montauk was the perfect perch for Warhol's fabulous freak show of heiresses, drag queens, beautiful young upstarts, and celebrities.

On any summer weekend at Eothen you might find Lee Radziwill and Jackie O hiding out under Hermès scarves, Catherine Deneuve sizing up Halston, the Rolling Stones rehearsing for a tour, or Marisa Berenson sunbathing on a bed of sea kelp. Unlike the Manhattan lofts where Warhol and his young "kids" (as he called his workers) lived, worked, and partied, the compound in Montauk was rustic. It was a series of simple cottages with wood-paneled walls designed for fishing tackle, not hipsters in platform heels. But Warhol's signature high-low style still worked: His parties in Montauk are as legendary as any back in Manhattan. And just as he did at the Factory, Warhol would take it all in while standing off to the side, Polaroid in hand, tape recorder running.

The goings-on at Eothen were even more decadent when contrasted with the blue-collar backdrop just beyond the driveway. Located on the easternmost tip of Long Island, Montauk is a remote fishing village with violent winter seas and blue-fingered temperatures. In the summer, the town mellows

Sean and Rachelle MacPherson and their dog, Stanley, at their Montauk home.

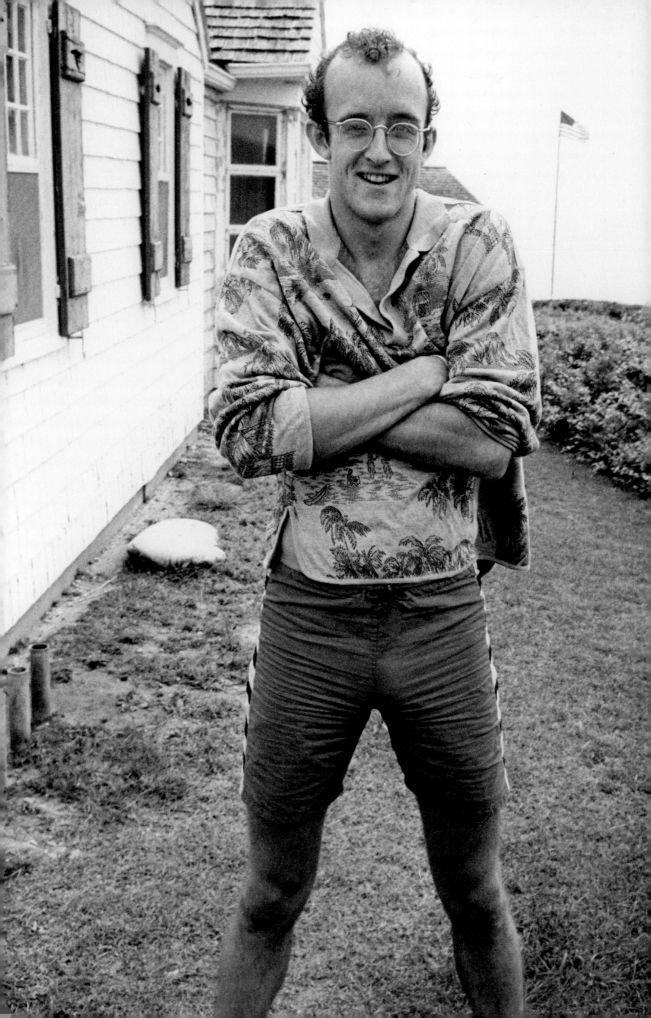

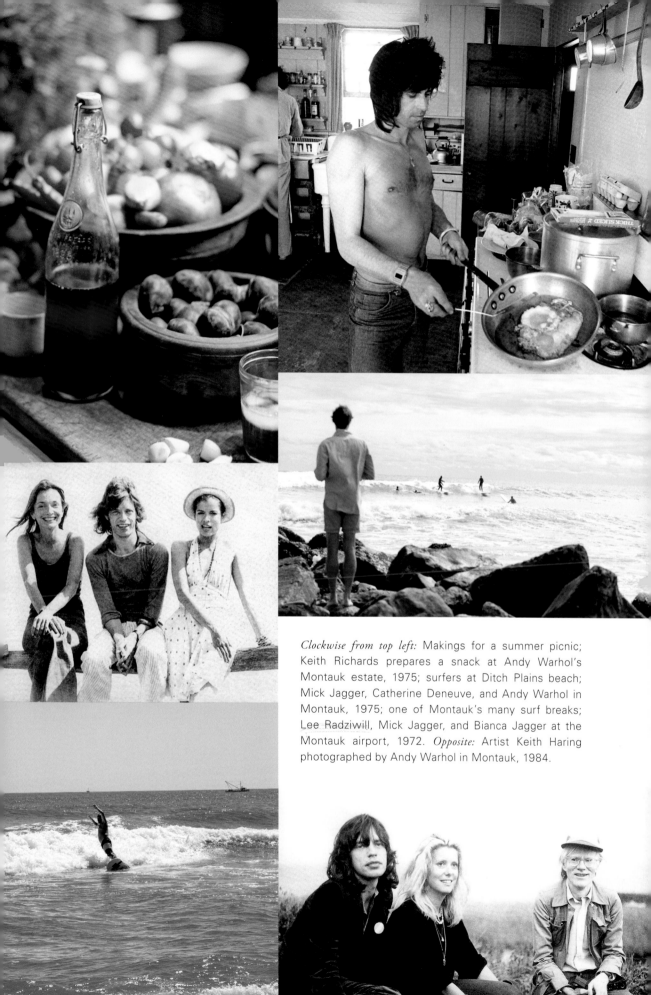

Clockwise from top left: Makings for a summer picnic; Keith Richards prepares a snack at Andy Warhol's Montauk estate, 1975; surfers at Ditch Plains beach; Mick Jagger, Catherine Deneuve, and Andy Warhol in Montauk, 1975; one of Montauk's many surf breaks; Lee Radziwill, Mick Jagger, and Bianca Jagger at the Montauk airport, 1972. *Opposite:* Artist Keith Haring photographed by Andy Warhol in Montauk, 1984.

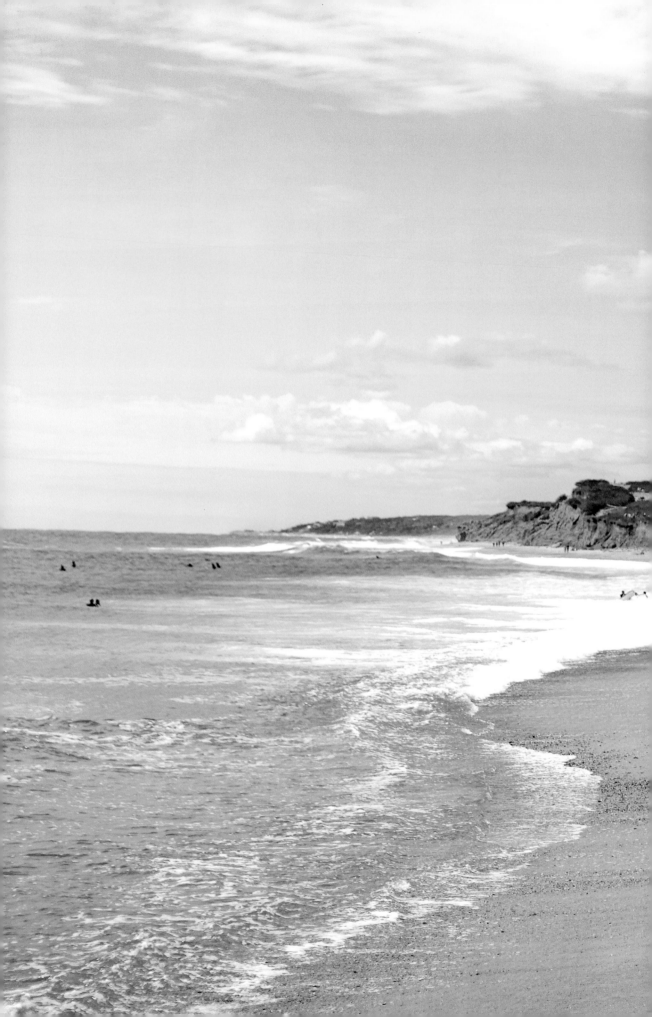

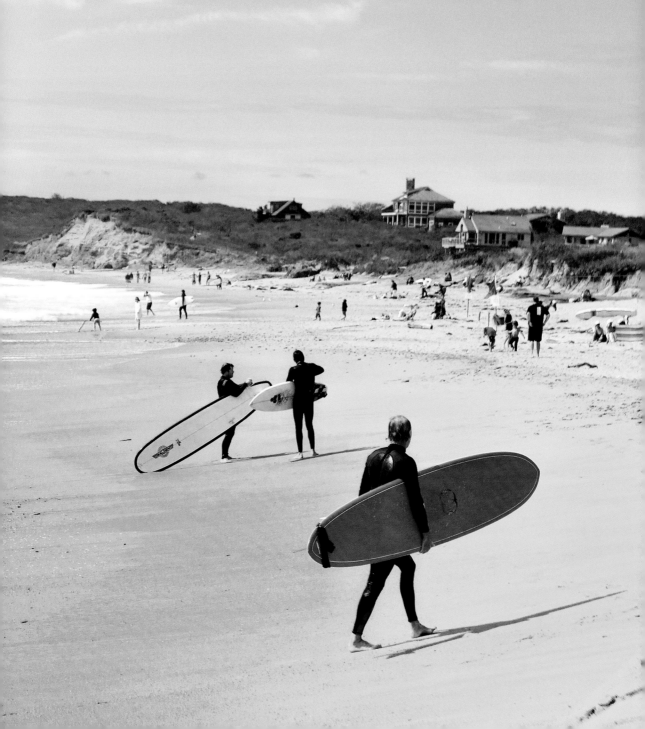

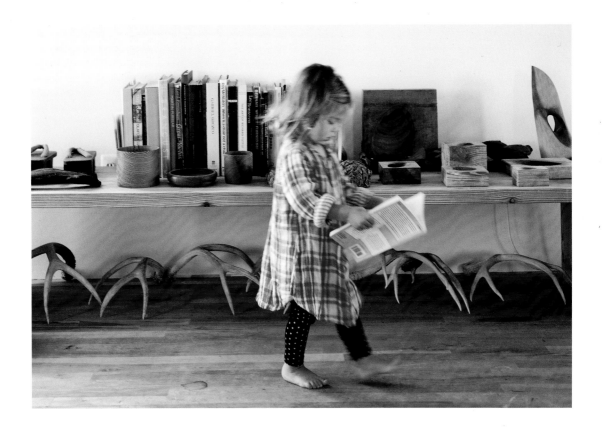

into a seaside resort catering to budget-minded families staying at motels with names like Seawind and Briney Breeze. Either way, it was galaxies away from Warhol's Factory and druggy glamour.

The town now has its share of foodie restaurants and chic boutique hotels. Manhattan has come to Montauk, but in true gypset fashion, things have been kept casual and beachy. The East Deck Motel, a postwar relic, still has the original streamlined kitchenettes and neon sign. But because the rooms overlook the best surf break in town, it's the coolest place to stay on the East End—if you can get a reservation, that is.

"Montauk has extreme highs and extreme lows," says hotelier Sean MacPherson. "You have rednecks mixed with movie stars, but everyone must navigate the same rural rawness." Sean, who grew up surfing between Hawaii's North Shore; Byron Bay, Australia; and Malibu, can often be seen putting around between his home and restaurant, the Crow's Nest, with a few surfboards poking out of the back of his vintage VW Thing. "It reminds me of the places where I grew up in the 1970s."

Gypsetters pilgrimage here for the rolling pastures, rocky prehistoric cliffs, and spontaneous parties. They come for an alternative to the money-obsessed Hamptons scene just fifteen miles away. In Montauk, a one-room surf shack carries more cred than a mansion; cheap motel rooms are abundant; and bare is the footwear of choice. Artists and surfers far outnumber bankers. Although some bankers are surfers, and some artists aren't artists, but that's another story.

Previous pages: The scene at Ditch Plains. *Above:* Gray catches up on her summer reading.
Opposite: Designer Rogan Gregory's handmade living room.

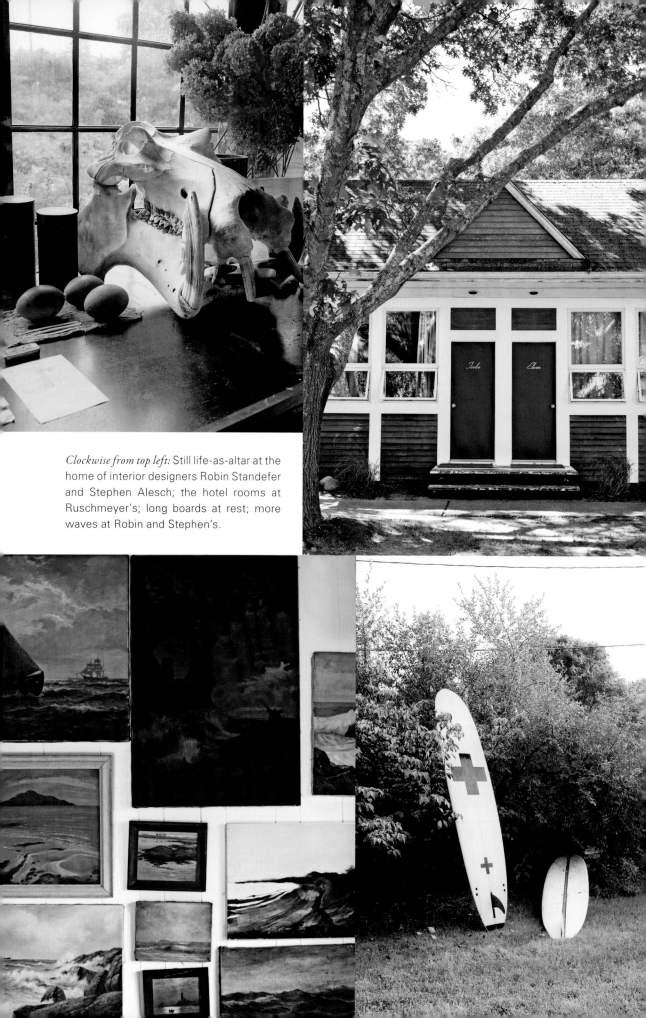

Clockwise from top left: Still life-as-altar at the home of interior designers Robin Standefer and Stephen Alesch; the hotel rooms at Ruschmeyer's; long boards at rest; more waves at Robin and Stephen's.

I love some of the creative homes in Montauk—people transforming small lots and tiny cottages into their seaside Tara. Like the shingled geodesic dome with ferns spidering across oddly shaped windows at the end of aptly named Paradise Lane. And the rickety salt-box that fashion designer Rogan Gregory customized into a surfer's retreat, with a coat of black paint and minimalist furnishings—all handmade in his woodshop downstairs. That, to me, is true glamour.

Montauk remains gypset largely because of its difficult geography—the last line of defense in an overly accessible and publicized world. To get there during high season, you must endure hours of standstill traffic on the tiny two-lane Route 27, making it impractical for weekenders. Or as Sean puts it: "It weeds out the weak." Gypset enclaves are hard to reach by definition—ideally three hours from an international airport: too far to venture for the uncommitted. For those who do make it out to Montauk, there is not much to see. The town just looks like a strip of T-shirt shops, pancake houses, and splintery seaside motels—all flying American flags. But spend a bit more time and a funky texture begins to emerge.

Ditch Plains, a densely populated neighborhood near the main surf beach, is where the action is. Summer is a fantastic mix of teenagers on skateboards with sun-bleached hair; city hipsters with asymmetrical bathing suits; families toting arsenals of beach furniture; and the occasional visiting surf star like Joel Tudor, Herbie Fletcher, or the Paskowitz family. Tudor can usually be found at the East Deck Motel, but Fletcher prefers to crash at his artist and filmmaker friend Julian Schnabel's house down the road.

In the surf world, Ditch Plains is often compared to Waikiki. Both beaches have a point break that triggers a long, cresting, mellow wave that dozens of longboarders can share at once. It's practical because July and August bring Hawaiian-size crowds to the beaches in Montauk. Yet the spirit of aloha pervades. I once left my flip-flops on the beach, and when I remembered to get them a week later, they were still there.

Before Warhol, there was Carl Fisher. A turn-of-the-last-century real estate mogul, Fisher was jet set before there were even jets, and made his fortune building Miami Beach. Visionary—or delusionary—in the 1920s, Fisher set out to transform Montauk into an unparalleled luxury resort for the Gilded Age elite. He planned to develop the town into the "Miami of the North," but the Great Depression ruined his dreams, forcing him to sell his land at rock-bottom prices. In the '60s, budget motels popped up on the unwanted holdings along with prefab Leisurama homes that Macy's department store sold for a few thousand dollars. In the 1970s, a handful of artists began to arrive.

The photographer Peter Beard bought a wild parcel of terrain down the coast from Warhol. When Beard's main house accidentally burned down, he simply took up residence in the caretaker's cottage and repurposed the charred foundation as a dance floor.

Following pages: The surfboard hitching post at Ditch Plains. *Pages 26–27:* The yogis from Love Yoga Studio Montauk (clockwise from the roof: Kathleen Stensen, Jeff Schwartz, Sian Gordon, and Heather Lilleston in *eka pada rajakapotasana pose*).

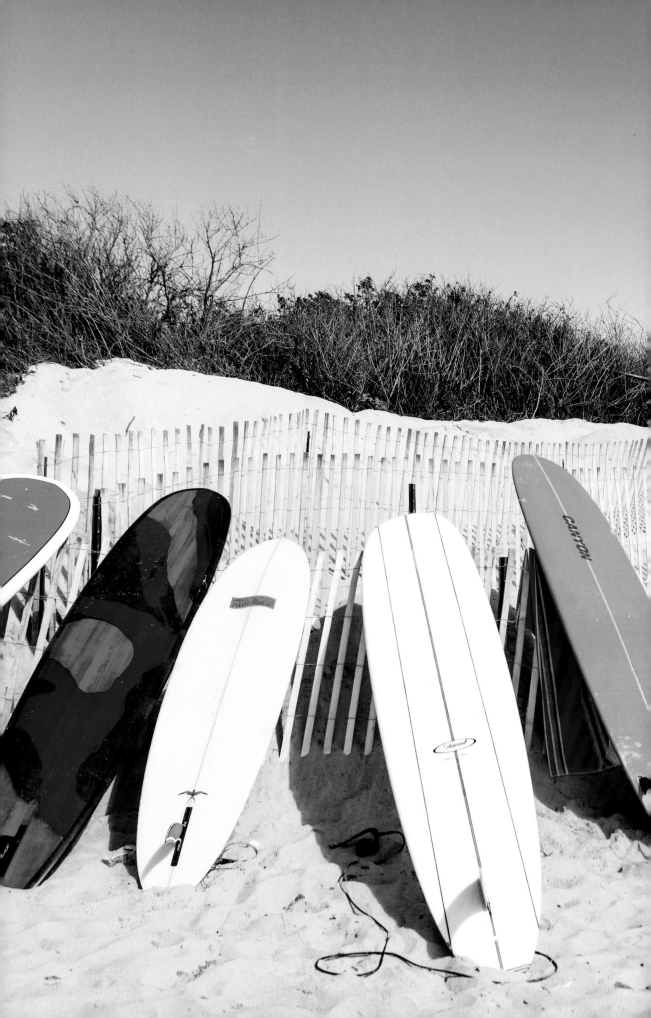

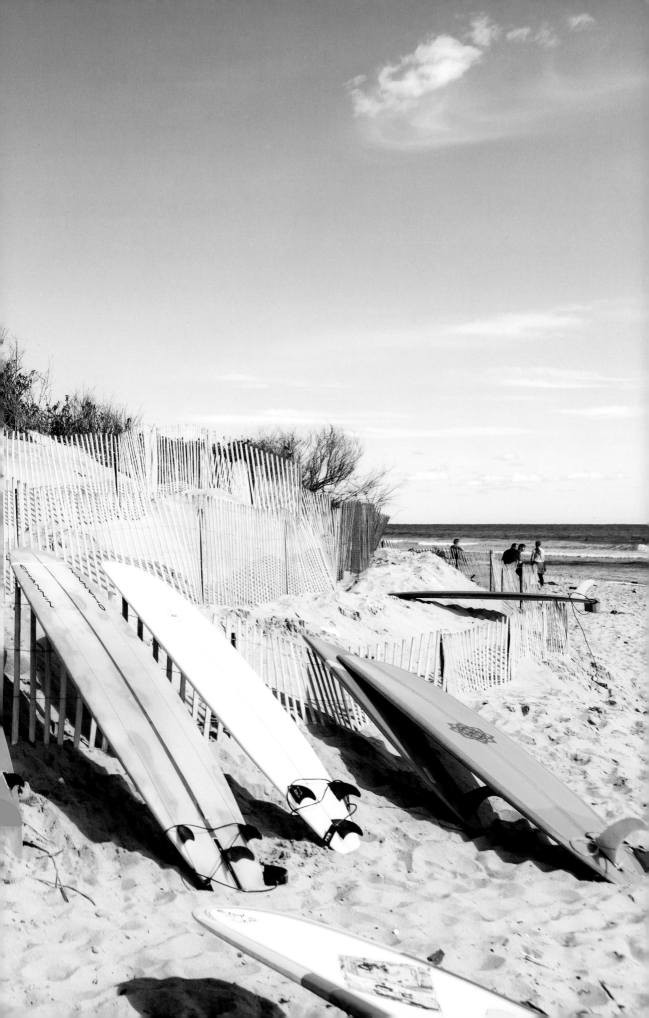

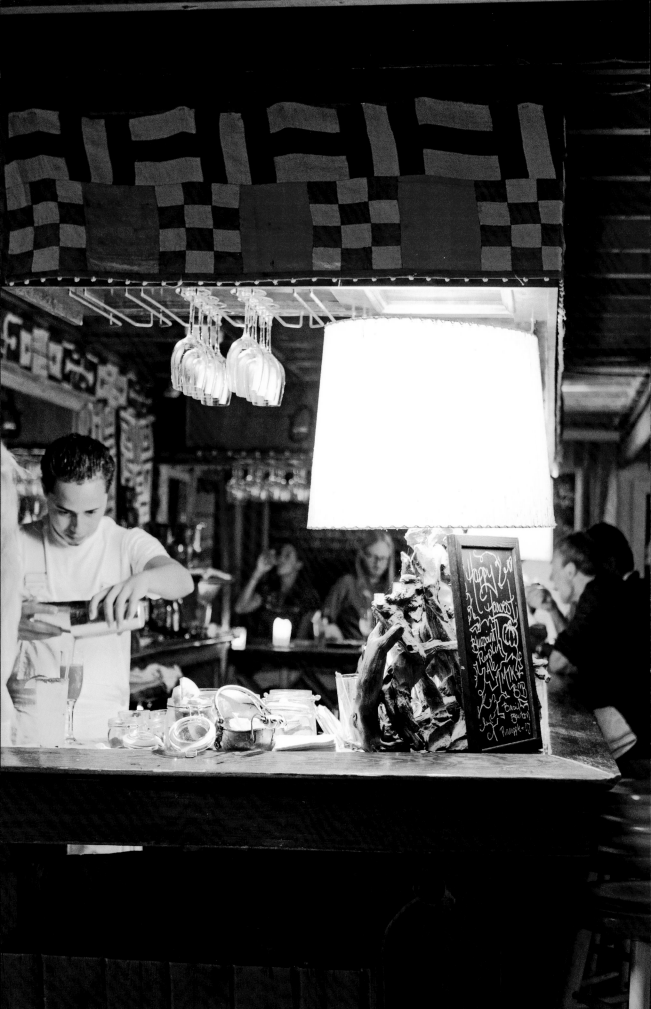

Above: Nighttime at the Crow's Nest.
Left: The bar at Liar's Saloon.

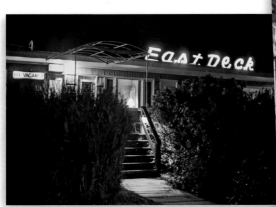

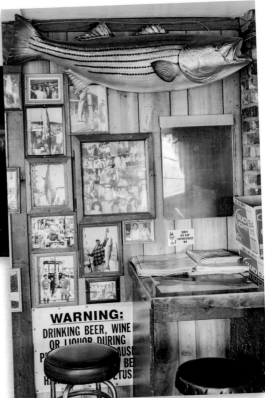

Above: Mid-century neon
at the East Deck Motel.
Right: Fishing memorabilia at Liar's.
Opposite: Mixing cocktails at the
Crow's Nest restaurant.

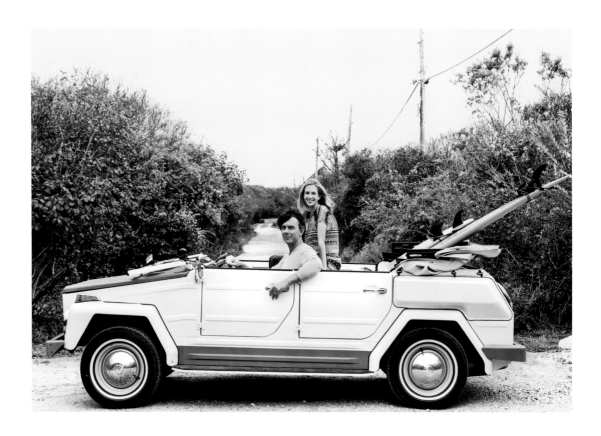

Wander down the right road in Montauk and you'll find that ethos still intact. Summer parties tend to spill out onto wooden decks and gangs of revelers hop from door to door. One particular July evening I followed some friends down an overgrown path. A Viking-esque blond was tending to an iron skillet over a fire pit. When he saw me, he grabbed my glass of red wine and poured it into the paella he was frying up. My hosts turned out to be Robin Standefer and Stephen Alesch, interior designers whose firm, Roman and Williams, did the Standard and Ace hotels in New York City, among other places.

The couple found a decaying 1950s "contractor's special" and converted it and its environs into a utopian party wonderland. "We treated it more like a camp," says Robin, who was brought up by a hippie mom, a fashion model who traveled between southern Spain, Morocco, and New York. Distressed wood tables welcome wet beer rings, and the stable-like doors to the house are left open, so guests can wander freely. If you get cold as the evening wears on, Robin has a collection of Peruvian and Chilean ponchos hanging in the hall.

Afterward, as often happens in Montauk, the party moves down to the beach for a bonfire. There's nothing to do but curl up next to it and watch the stars—a million miles from anywhere.

Above: Sean and Rachelle MacPherson troll for surf in their vintage VW Thing.
Opposite: Jason Miller sunning with daughter, Tuesday. *Following pages:* Rogan Gregory relaxes on his front stairs; Bethany Mayer and daughter, Gray, at her Surf Bazaar boutique.

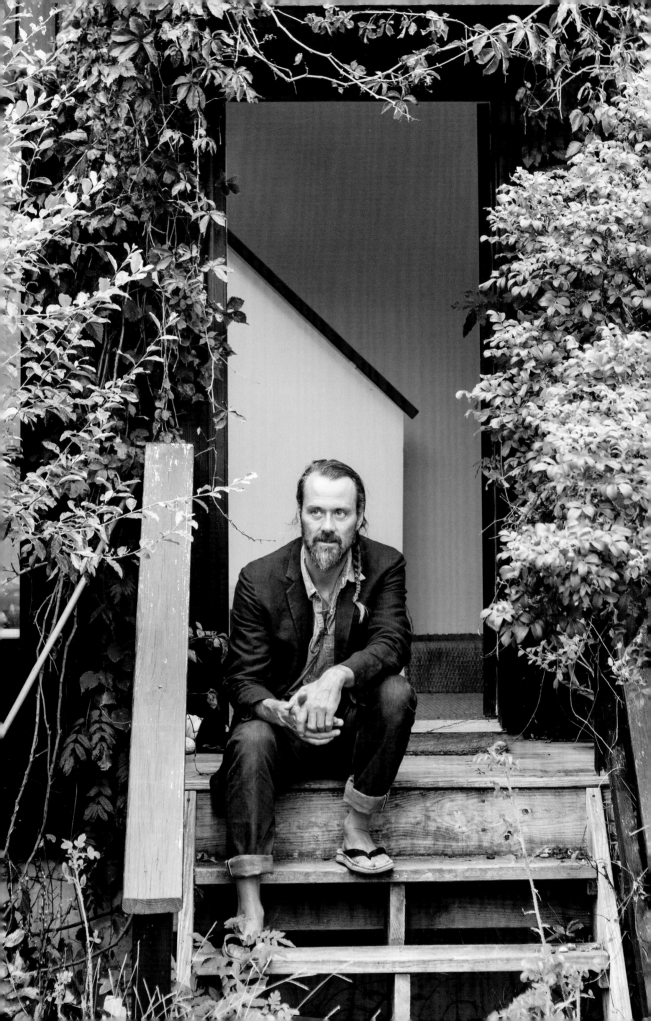

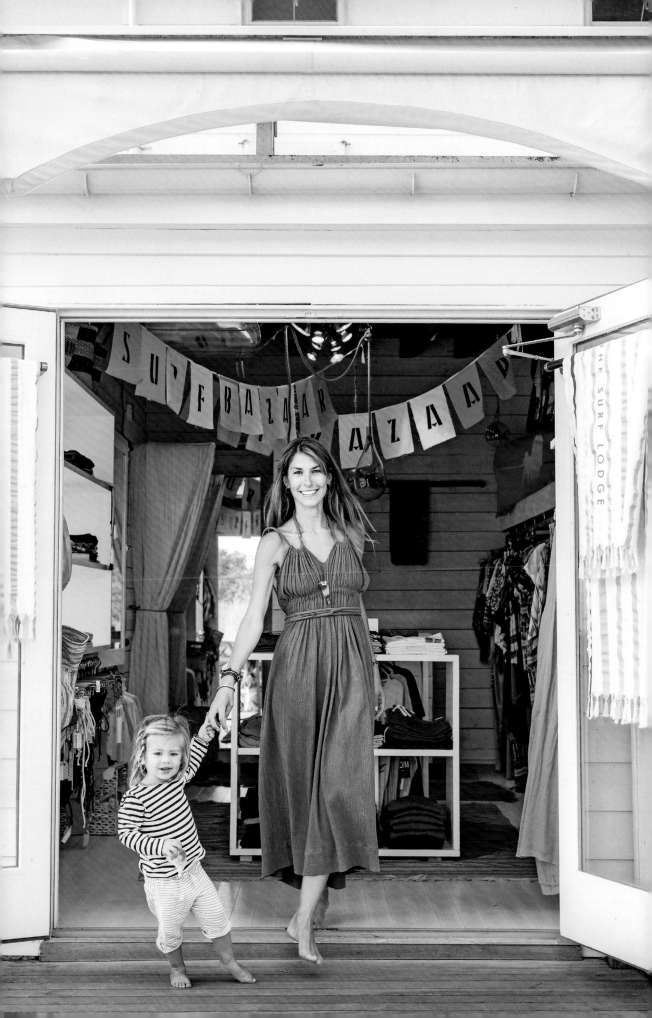

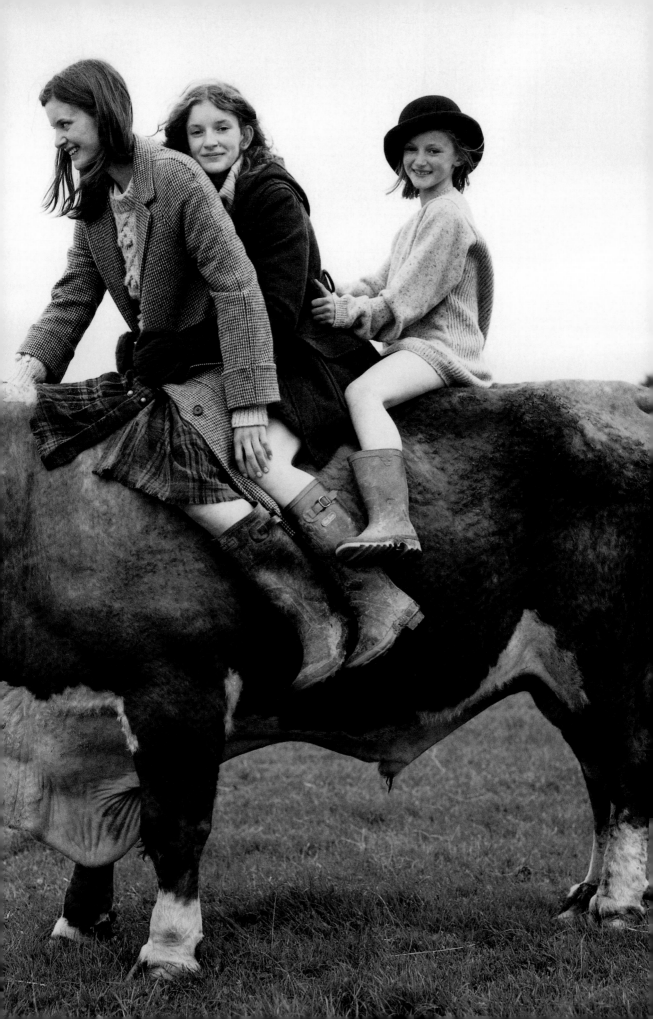

WEST COUNTRY

"It's been tough on the cows."

MICHAEL EAVIS, Glastonbury Festival founder

The West Country has been a magnet for freaks and mystics since medieval times. This swath of southwest England includes the impossibly green counties of Somerset, Devon, Dorset, and Cornwall. Pagans, Celts, druids, out-and-out charlatans, and ethereal goddesses have all been drawn to the West Country's lush pastures and wooded knolls, bringing in their wake the scents of patchouli oil and weed.

Glastonbury—the storied town in Somerset—is said to be the isle of Avalon once visited by a teenage Jesus Christ and where King Arthur lived; the king's legendary sword is even believed to be buried there. In the 1960s Baronet Mark Palmer, a close friend of Mick Jagger's, went in search of a Shangri-La in Cornwall. He traveled around in druid robes in a horse-drawn gypsy caravan for decades, touring Britain on a mission to find the Holy Grail.

Around the same time, Michael Eavis, a young entrepreneur with a 150-acre dairy farm a few miles from Glastonbury, had a money-making idea: He would throw a folk-rock concert for wanderers like Palmer. T. Rex was the headliner, and the 1,500 tickets—purchased by tossing a £1 coin into a dairy churn tied to a jeep—included free milk from his cows. It was the first Glastonbury Festival. "There's a kind of euphoria down here," a bearded Michael gushed to a BBC reporter at the time.

Thanks in part to the festival, the town of Glastonbury remains a seeker's nexus. Modern-day pilgrims gather downtown, at places like the Rainbows End Cafe, barefoot and garlanded for their enlightenment. The Glastonbury Goddess Temple draws women near and far to its esoteric ceremonies

Opposite: Hitching a ride on a furry friend through the fields of the West Country
Following pages: Festivalgoers gather in July on the fields of Cornwall's Port Eliot estate.

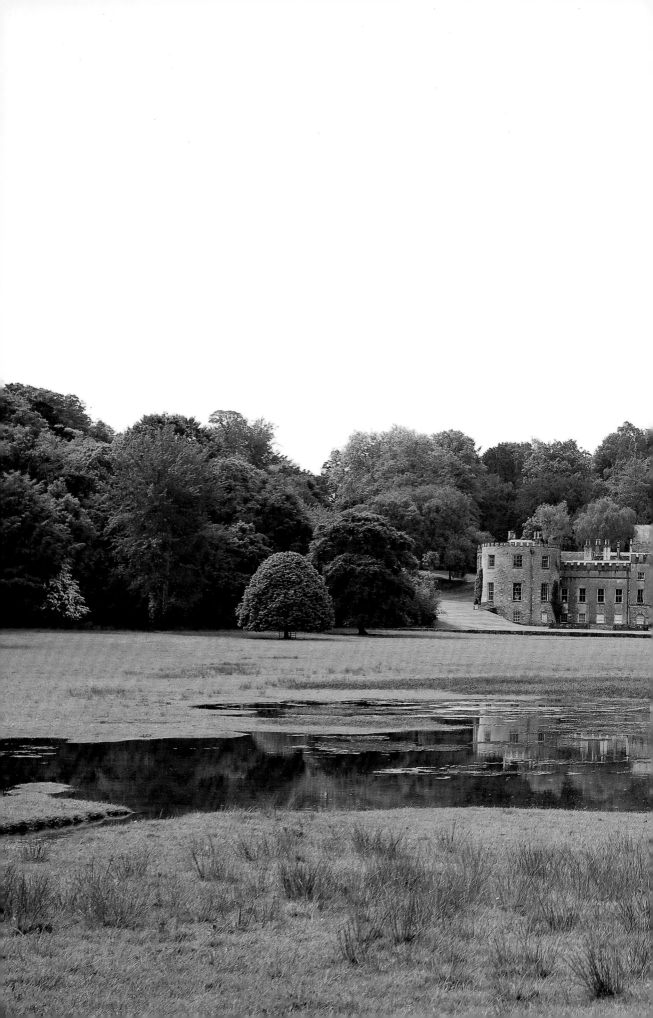

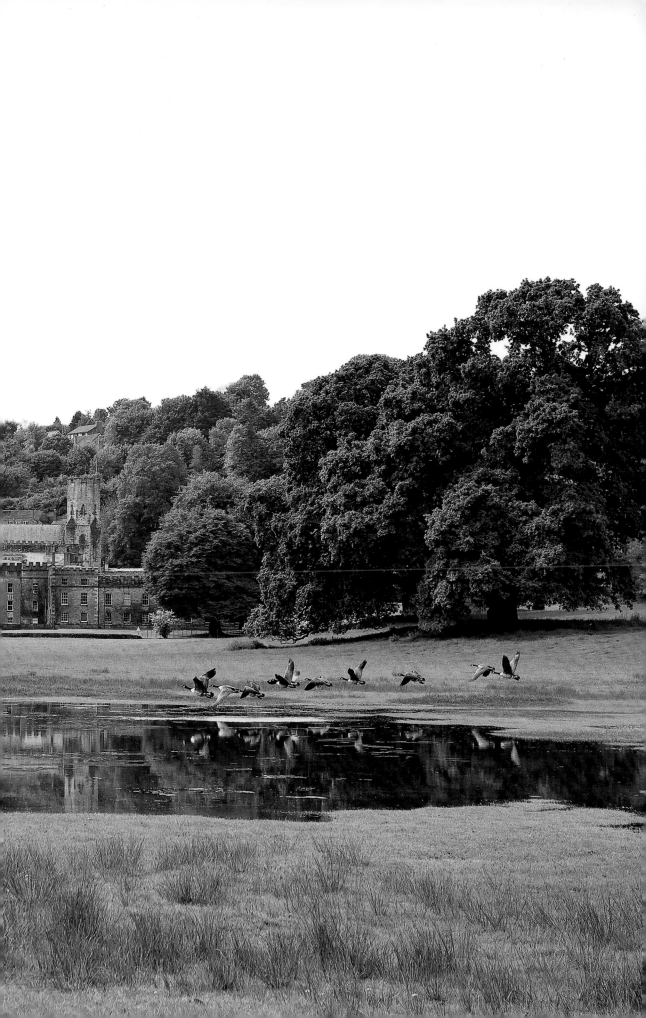

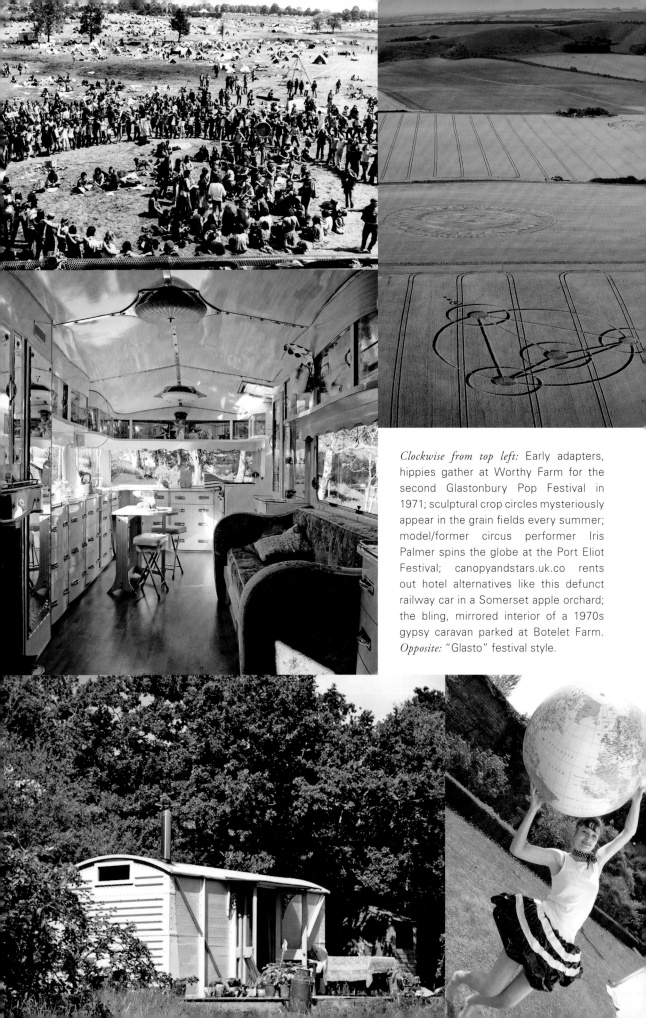

Clockwise from top left: Early adapters, hippies gather at Worthy Farm for the second Glastonbury Pop Festival in 1971; sculptural crop circles mysteriously appear in the grain fields every summer; model/former circus performer Iris Palmer spins the globe at the Port Eliot Festival; canopyandstars.uk.co rents out hotel alternatives like this defunct railway car in a Somerset apple orchard; the bling, mirrored interior of a 1970s gypsy caravan parked at Botelet Farm. *Opposite:* "Glasto" festival style.

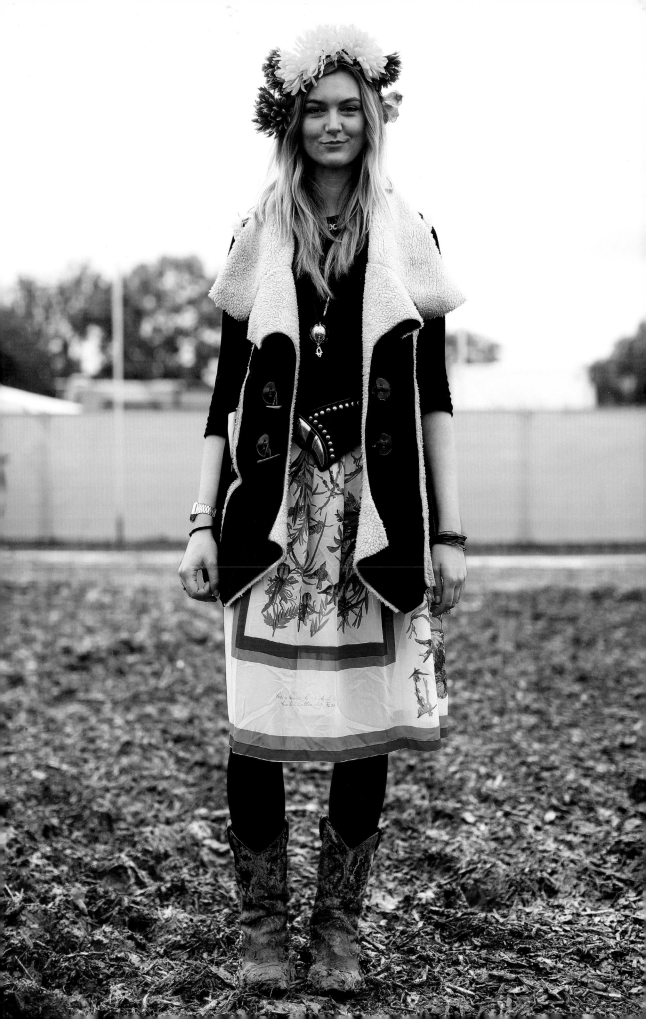

and priestess trainings. The London fashion crowd slums it—partying pagan-style in tepees at weekend-long benders hosted by designer Alice Temperley on the grounds of her farm. (Tepees aren't exactly pagan, but who's counting?) And then there are those who come for a glimpse of the intricate crop circles that mysteriously appear among the grain fields every summer like billboards for passing UFOs. Are the creative culprits tongue-tied aliens or crafty humans? It depends on who you ask.

The Glastonbury Festival today is the gold standard of neo-hippie gatherings, a temporary fantasyland that pops up just in time for the summer solstice. Over 150,000 "punters" come for a long weekend of round-the-clock entertainment: everything from rappers and circus acrobats to meditation gurus. There's a hundred-foot-high main stage built in the shape of a pyramid; Green Fields, an environmental area filled with peace flags, wind generators, and rows of tepees; and Shangri-La, an after-hours hangout zone inspired by the aesthetic of *Blade Runner*. "Glasto" has become an adjective in the fashion world. You know the look: You've seen it on It girls like Kate Moss and Sienna Miller. It's some combination of denim cutoffs, a straw fedora, and muddy wellie boots.

But the event has experienced growing pains en route to the mainstream. In 2000, thousands of gate-crashers mauled the party (along with the one hundred thousand who bought tickets), forcing Michael to build a sort of U.S.–Mexico border fence around his farm. Michael said in 2011 that the festival has "probably got another three or four years" before its last hurrah. (Although the year before, he also said he saw "no signs of giving up," so it's hard to know what to make of these proclamations.)

Above: Mongolian yurts are the address of choice during summer festivals.
Opposite: Guarding the entrance to the Port Eliot estate. *Following pages:* Dilapidated glamour reigns at the rambling estate, which has one hundred rooms and two hundred bats.

Whatever happens, splinter festivals have cropped up around the countryside, each promising a cooler, more niche event. There's Bestival, for the eco-minded; the Secret Garden Party, a wacky outdoor rave; and All Tomorrow's Parties, an alternative music festival.

Of course the challenge for any gypsetter is to ferret out creative energy at the right time. I recommend following the coast down toward Cornwall, which some maintain is its own kingdom. It has a subtropical climate and abundant, empty surf breaks. It's a real thrill to sleep at a farm, drive ten minutes, and surf in a place where you can see cliffside castles from the lineup. And it was in Cornwall that I looked up Perry (Earl Peregrine St. Germans) and Cathy (Lady Catherine, a fashion journalist). The couple runs a literary festival on the grounds of Port Eliot, Perry's ancestral home in a converted monastery that dates back to the tenth century. It's a bohemian Downton Abbey with one hundred rooms but only eleven radiators (and, apparently, two hundred bats). When I needed a spoon at lunch, we left the dining room and trekked miles down the hall to find the one pantry (of several) that contained nothing but silver utensils. It was really a workout.

The St. Germans winter in Oahu, Hawaii, where they keep a simple bungalow overlooking Waimea Bay. Their backyard is a front-row seat for watching the Triple Crown of Surfing contests during the winter big wave season. The couple has befriended a lot of the North Shore surfers, so it's not uncommon to see blond heads and board shorts wandering the paneled halls of Port Eliot in the summer.

Above: The ultimate luxury; houseguests can pick from an assortment of gumboots. *Opposite:* Shoes not required; Clementine Campbell with Cathy St. Germans's blue whippets, Lark and Roo.

The estate is wonderfully dilapidated. Centuries-old silk wallpaper peels off in shards, and there's a banquet-size dining room with no electricity, but lots of candles. Perry and Cathy keep their collection of vinyl LPs inside an heirloom armoire. Family portraits that have accumulated for five hundred years line the walls, but the one of Perry and Cathy was airbrushed onto an old broken surfboard by the Hawaiian artist John Bain. Perry, who describes himself as "hip but not a hippie," explains: "It would be easy to live life in the highly privileged aristo-ghetto, but we've never wanted to do that."

Like the early days of Glastonbury, the Port Eliot Festival, which started in 2003, is an intimate gathering of like-mindeds. Only a few thousand "punters" camp out on family land. The festival has a literary theme, which does wonders for warding off the E-gobbling rave crowd. Instead of Glastonbury's mud, there are hidden mazes and rhododendron groves.

The festival is a playful mixture of literary happenings, musical performances, and DIY fashion. In recent years, it has featured Kate Winslet reading children's stories, Jarvis Cocker DJing, and fashion designer Luella Bartley, who lives in Cornwall, dressing guests in paper outfits including Iris Palmer (the model–circus performer daughter of wandering baronet Mark Palmer).

For now, Port Eliot remains below the radar and very gypset. "Every eighth person should be someone you know," says Perry. Along with a good number of authors, surfers, and hippie socialites, a percentage happen to be the offspring, ex-wives, and friends of the Rolling Stones. Keith Richards's ex-wife, Anita Pallenberg, and their son, Marlon Richards, are regulars. Chef Daniel de la Falaise, Marlon's brother-in-law, serves up gourmet food. It also seems like everyone has a cousin with a glamping (glam camping) business, supplying tepees and yurts tricked out with luxury amenities such as high-thread-count sheets and Turkish rugs.

So far, unlike at Glastonbury, there haven't been gate-crashers at the mansion. Of course it helps that there aren't any VIP areas and few "keep out" signs. Revelers stream in and out of the house and gather in the round room, a stately parlor with a domed ceiling, a psychedelic mural, and Perry's vintage Harley-Davidson.

"Everyone is allowed inside," according to Perry. And who can blame the ones that decide to plunk down and stay a while? "Sometimes I'll be wandering around the house," says Cathy, "and find a guest left over in one of the rooms."

Previous pages: Lady Cathy, co-founder of the Port Eliot Festival, hangs out with friends from Oahu's North Shore: skateboarder Greyson Fletcher, surfer brothers Nathan, Ivan, and John John Florence, the 2011 champion of the Triple Crown of Surfing.

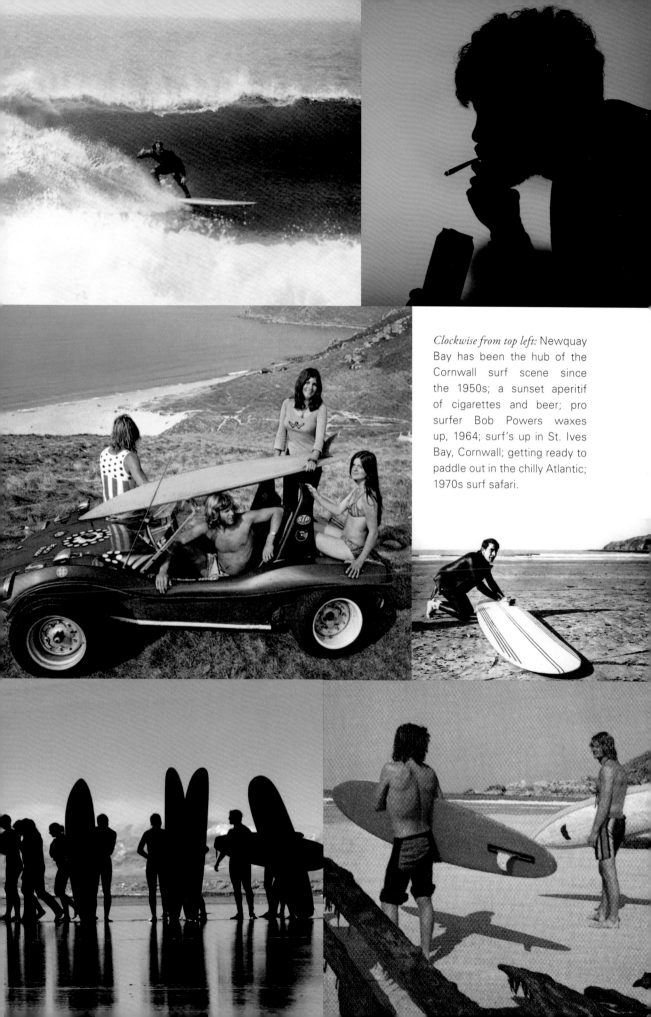

Clockwise from top left: Newquay Bay has been the hub of the Cornwall surf scene since the 1950s; a sunset aperitif of cigarettes and beer; pro surfer Bob Powers waxes up, 1964; surf's up in St. Ives Bay, Cornwall; getting ready to paddle out in the chilly Atlantic; 1970s surf safari.

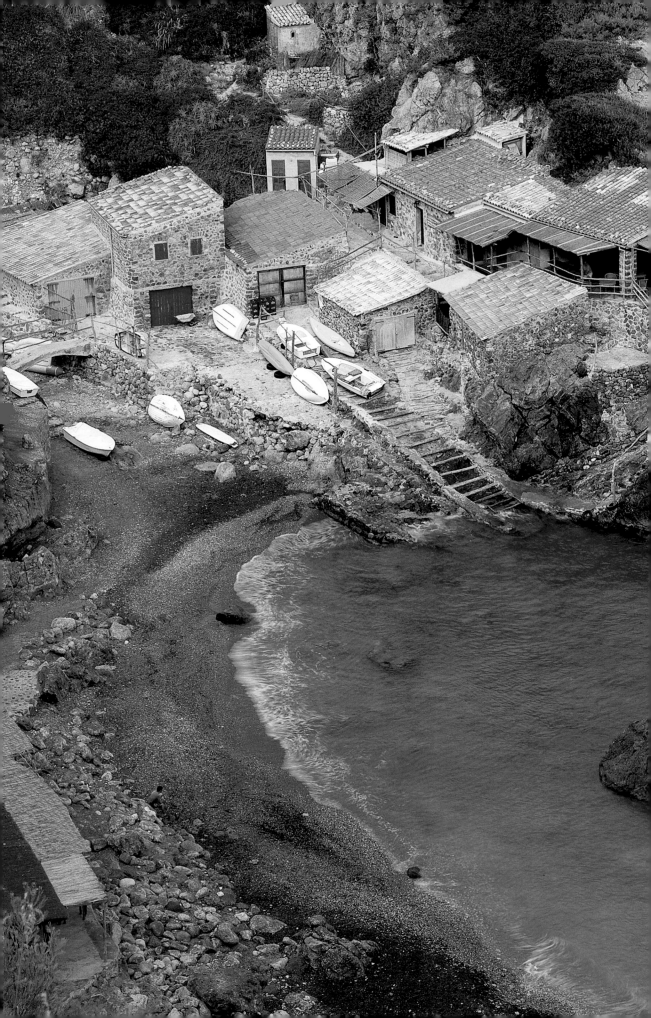

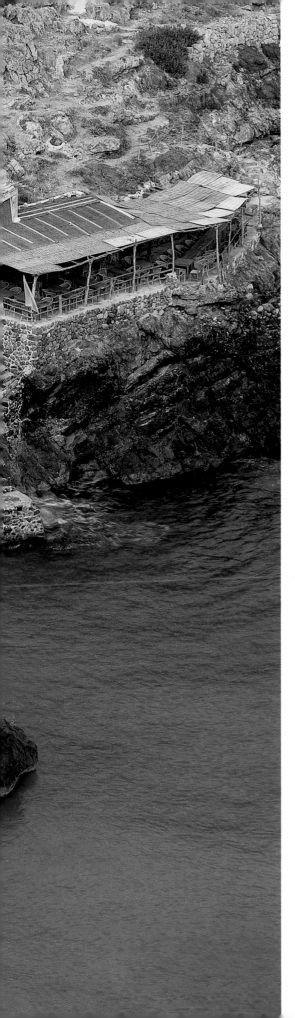

DEIÀ

"Paradise—if you can stand it!"
GERTRUDE STEIN

Art patron Gertrude Stein, holding court from a lounge chair in her Parisian salon at 27, rue de Fleurus, moonlighted as a gypset travel agent. She had a knack for prescribing the perfect exotic retreat to remedy her artist friends' suffering from creative blocks, financial troubles, and social malaise. In so doing she anointed many of today's gypset enclaves. Most famously, she directed Ernest Hemingway to Pamplona, Spain, in the 1920s, which inspired his novel *The Sun Also Rises* (1926). She recommended Antibes in the south of France to F. Scott and Zelda Fitzgerald. But it was also Stein who had the brilliant intuition to send the young English poet and novelist Robert Graves off to the ancient seaside village of Deià, on the Spanish island of Majorca.

Beach and houses in the Cala de Deià bay.

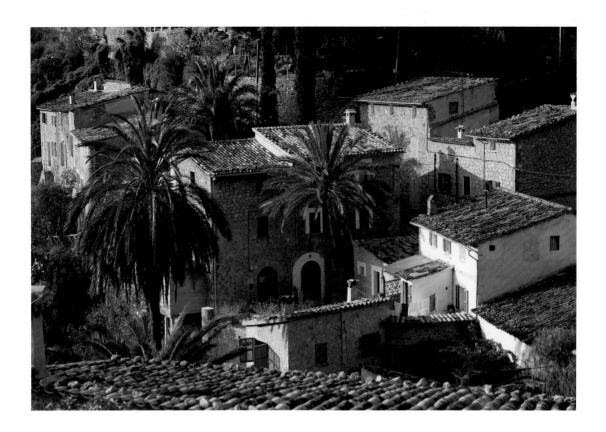

Graves arrived in 1929 fresh from a divorce scandal in England, with his lover, the poet Laura Riding, in tow. They set up in a stone cottage with a view of the Tramuntana mountains, founded a small printing press, and began to write. Eventually Graves's letters, full of gushing prose about a new promised (is)land, attracted a boatload of friends—including actors Alec Guinness and Peter Ustinov, as well as a young Gabriel García Márquez. Anaïs Nin rented a house near the monastery where Frédéric Chopin and his lover George Sand shacked up and wrote an erotic story entitled *Mallorca*.

Graves eventually authored more than one hundred literary works while living in Deià, including his masterpiece, *I, Claudius* (1934). "I found everything I wanted as a writer: sun, sea, mountains, spring-water, shady trees, no politics, and a few civilized luxuries such as electric light," he wrote about his enchanted isle. "Town was still town; and country, country."

By the 1960s Deià was a sort of Haight-Ashbury for expat creatives. Ibiza, about eighty miles away, was the more obvious and publicized choice for the hedonistic hippie looking for a party, but Deià became a shrine for a full spectrum of more sensitive souls: literary types scribbling into dog-eared notebooks; musicians like Jimi Hendrix, Kevin Ayers, and Jimmy Page; easel-toting artists perfecting the psychedelic-surrealist look; earthy fashion models; and trust-fund aristocrats desperately trying to write their masterpiece. Impromptu jam sessions involving flutes, flamenco guitars, and fezzes were the norm and afternoons were routinely spent—as they are today—in nudist swimming *calas* (coves) off the lapping Mediterranean Sea.

Above: Deià's historic architecture dates back to the tenth century.
Opposite: High noon in downtown Deià.

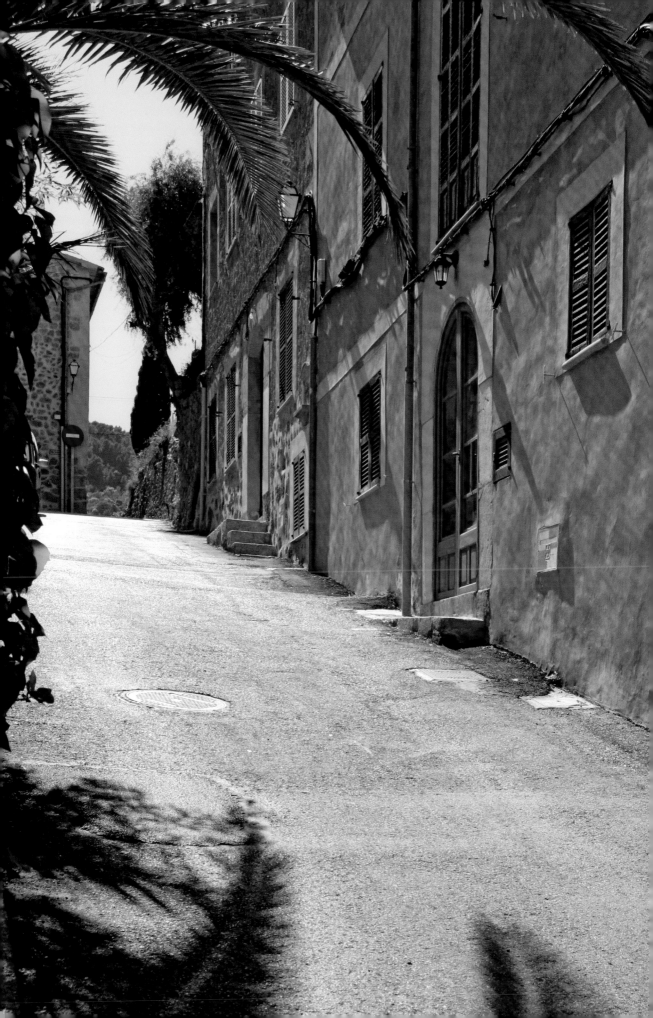

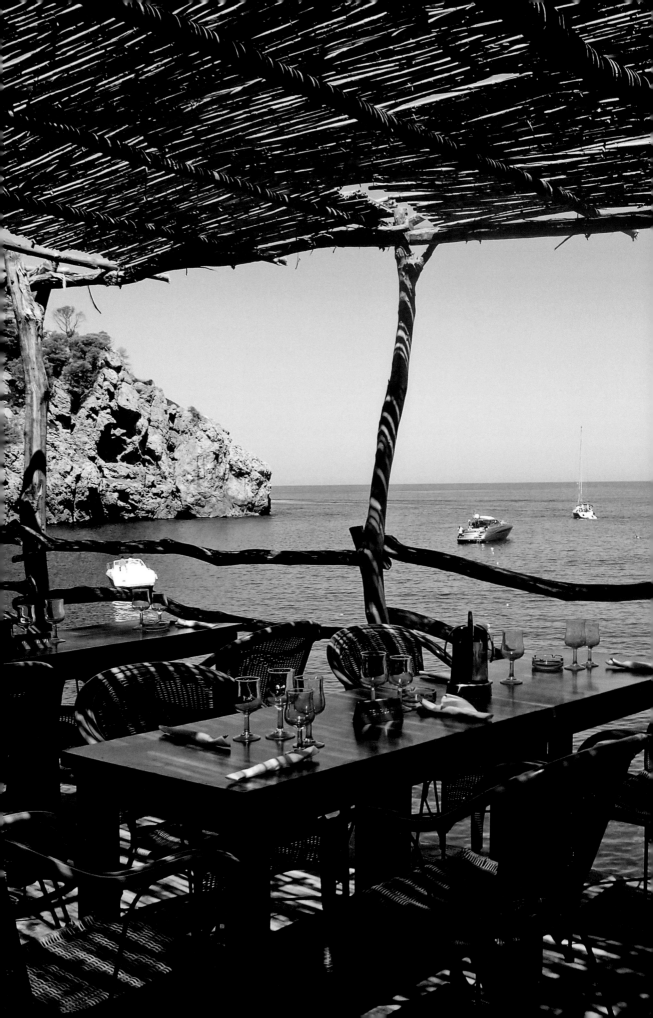

"They were trying to find a place where they could live with fewer rules, and where they could get drunk for very little money," says Aureliano "Oro" del Negro, a local architect whose father, Del Negro, a Spanish actor who appeared in Werner Herzog's *Aguirre, Wrath of God* (1972), was part of that early Deià scene. "It was so cold in the winters they'd all end up at Jaime's restaurant and drink sparkly white wine that got everyone totally bananas. Deià was a very big escape—a big party," Oro says.

Balthazar Klarwein, a young film director who splits his time between London and Deià, describes growing up in the liberal island village as "one big family from different backgrounds and places. There were breakups and lovers, and all the parents just took care of us all like one big pack." His father, the artist Mati Klarwein, studied under Fernand Léger and Salvador Dalí and became the go-to guy for trippy album covers, including Santana's *Abraxas* and Miles Davis's *Bitches Brew.* Mati—who grew up in the British Mandate for Palestine and in Paris—was on a boat to Ibiza in 1957, but bad weather forced a landing in Majorca's capital, Palma. He decided to look up a friend from New York, archaeologist Bill Waldren, who was living in Deià, and basically never left. Eventually Mati began dating the photographer and model Caterine Milinaire (who, coincidentally or not, was on the cover of my last book, *Gypset Style,* published in 2009). She became Balthazar's stepmother in the 1980s.

Deià's deep bohemian roots explain why an artist colony even exists on Majorca—one of the most popular tourist destinations in Europe. Over six million visitors descend each summer, drawn by Palma's stately mansions and reputation as an aristocratic vacation retreat. Yet Deià—a Moorish fishing hamlet that dates back to the tenth century and a fifty-minute drive from the Balearic capital—has remained commercially and socially preserved: a dysfunctional, lovable utopia hidden in plain view. CEO types have begun to trickle in, buying up pricey abodes, but they mainly keep to themselves.

It helps that Deià—with a population of about eight hundred—masquerades as your basic quaint, historic village. From a distance there's a poetic maze of old stone homes with terracotta roofs that practically melt into the mountains. Up close it's not much more than a couple of shabby little bars, a church, and nowhere to park. Even getting to the beach is a hassle—buses run infrequently, and walking down the steep, dusty paths that lead to the coast is a sure guarantee for sunburns, blisters, and thirst. Most tourists take a quick peek and then get back onto coastal highway. But in the evening, when the outsiders have left, Deià reveals its legendary self. As Oro del Negro explains, "it's a closed community of friends, dinners at people's houses, and all the doors are open."

The second- and third-generation members of the Deià scene, like Balthazar and Oro, mingle with the current wave: deep-pocketed but understated fashion photographers (Ellen von Unwerth, Bettina Rheims, and Mario Testino); cool actors like Anna Friel and Michael Douglas; and quite a few rock stars. (Note, most of this "current wave" has been coming to Deià for a decade or two; things move slowly here.)

Previous pages: Ca's Patro March restaurant in a pre-lunch lull.

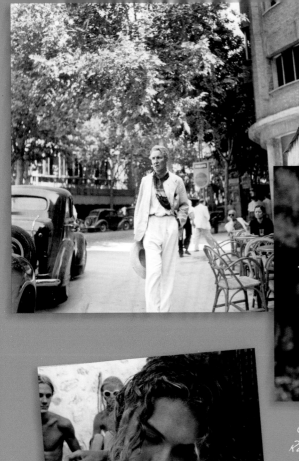

Clockwise from top left: Writer and poet Robert Graves strolls in Palma de Majorca, January 1954; Majorca was the location for the film *Evil Under The Sun* (1982); a teenage Aureliano "Oro" del Negro during the summer of 1994.

Nour Cavalcanti Bramly after a swim.

Above: Golden days of summer. Left: Glamping Deià-style.

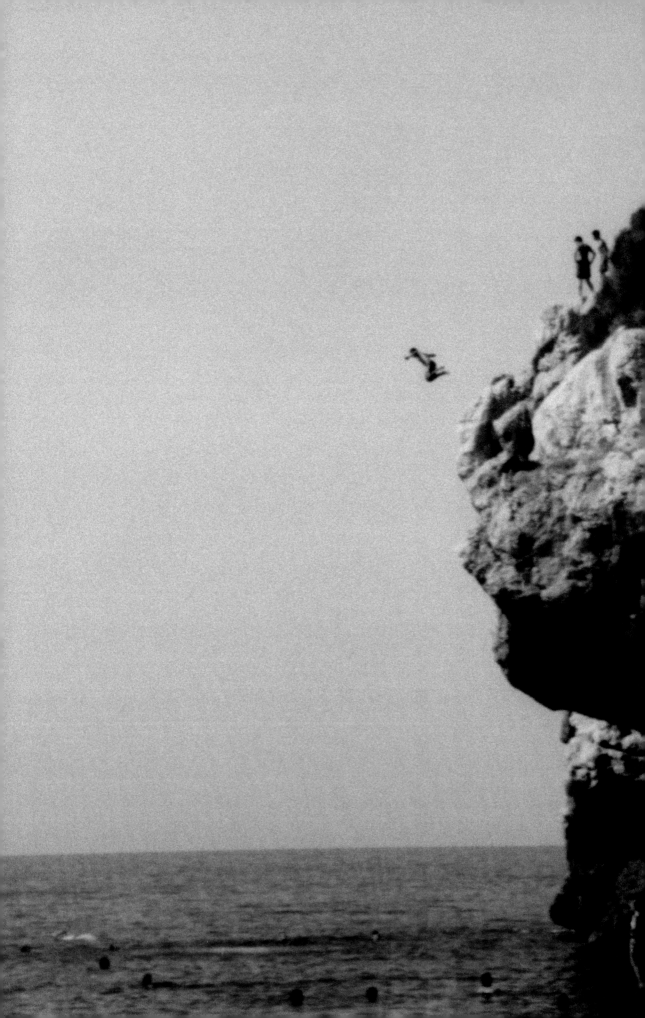

Starving artists can't afford the old rambling fincas anymore, making the present-day group of more commercially minded upstarts the heirs apparent. There's little chance they'll ruin the place, however. They've seen too much luxury to want it and too much fashion to wear it—at least in August, when they are all summering in Deià.

"Mostly there's a lot of battling with nature," says Alexandre de Betak, the French-born founder of Bureau Betak, an art direction and event production firm with luxury clients such as Rodarte, Lanvin, and Hermès. Betak retreats to Deià to be "cleansed" from his spin cycle commuting between offices in Paris, New York, and Shanghai. With the help of Oro del Negro, Betak transformed his traditional stone farmhouse into a barefoot-luxe vacation cave engineered for socializing—a commune where everyone is a guest and no one has to work. Inside, there's a long farm table perfect for large dinner parties replete with bowls of fresh pesto pasta and panini. Wine flows from a spigot in the kitchen wall, and the floors are made of soft pebbles that never seem to get dirty. Instead of a couch, there's a mound of large, comfy pillows covered in vintage military linen that Betak found at Paris's Porte de Clignancourt market.

Spontaneous creative collaborations still happen in Deià, but the difference is that now the key grip on your Youtube video might be

Making a splash at one of Deia's swimming *calas*.

59

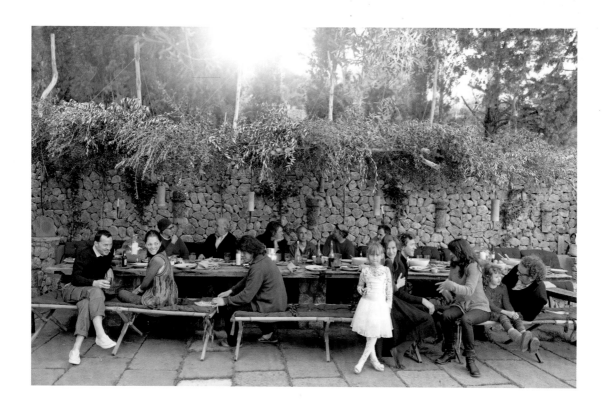

a viscount or a blockbuster actor. When musician Bob Geldof, a longtime Deià frequenter, wanted to make a music video for an upcoming album, he just turned to the guy sitting next to him at a bar. "He said, 'I don't care what it is but I want gangsters and car chases and blood and I don't have any money but I know you have a camera so let's have some fun,'" says Balthazar Klarwein, who instantly agreed to direct the short. They rustled up a few Deià friends: actor Rhys Ifans, Dan Macmillan (aka Viscount Macmillan of Ovenden), record executive Alan McGee, and Balthazar's younger brother, Salvador. They borrowed an old Mercedes sedan, and after two days of screeching around the winding roads, the film (for the song "Systematic 6 Pack") was completed.

The spot that brought this motley group together is Sa Fonda, a small dive bar. A microcosm of Deià, it's been the dimly lit setting for decades of romances, breakups, promises, hangovers, and more hangovers. Its location at the center of town means that at the end of the night, all the drunk and restless and their houseguest entourages end up going there. "There's a very interesting mix—beautiful people from all over the world—and the energy gets very high," says Oro. Llewellyn Graves, Robert Graves's grandson, can often be found DJing there, everything from Ali Farka Toure to break beats and back. As Oro puts it, "everyone is dancing; a super famous millionaire next to the local Mediterranean farmer and some teenager in a T-shirt. It's just the best time in your life."

Above: Lunchtime at Alexandre de Betak's house. *Opposite:* A Deiàn party nook.
Following page: Betak designed his cave-like house as a "twisted version" of the local architecture.

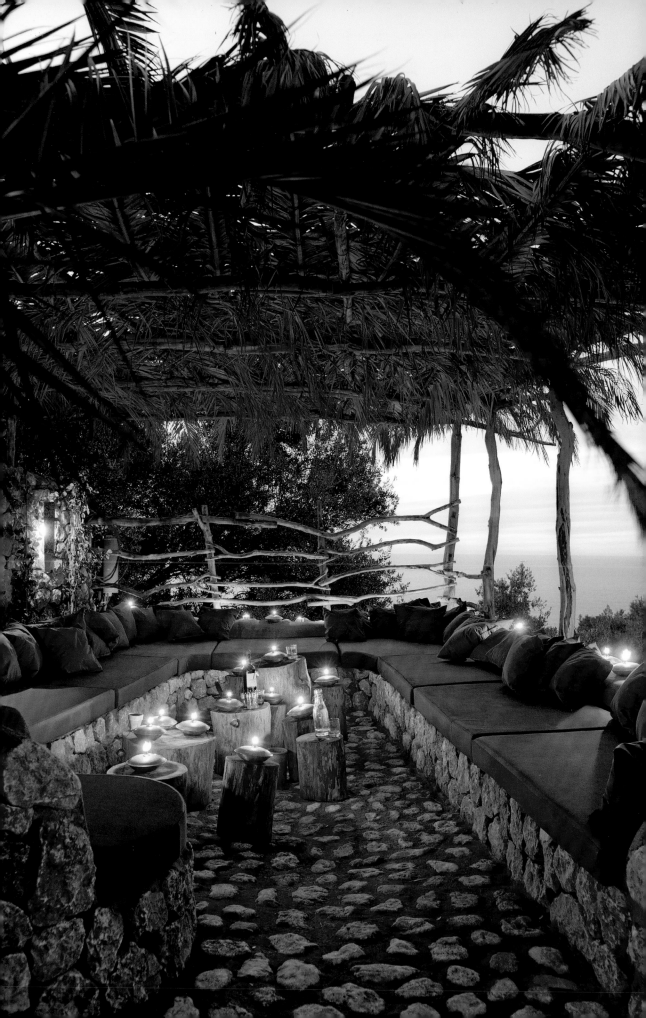

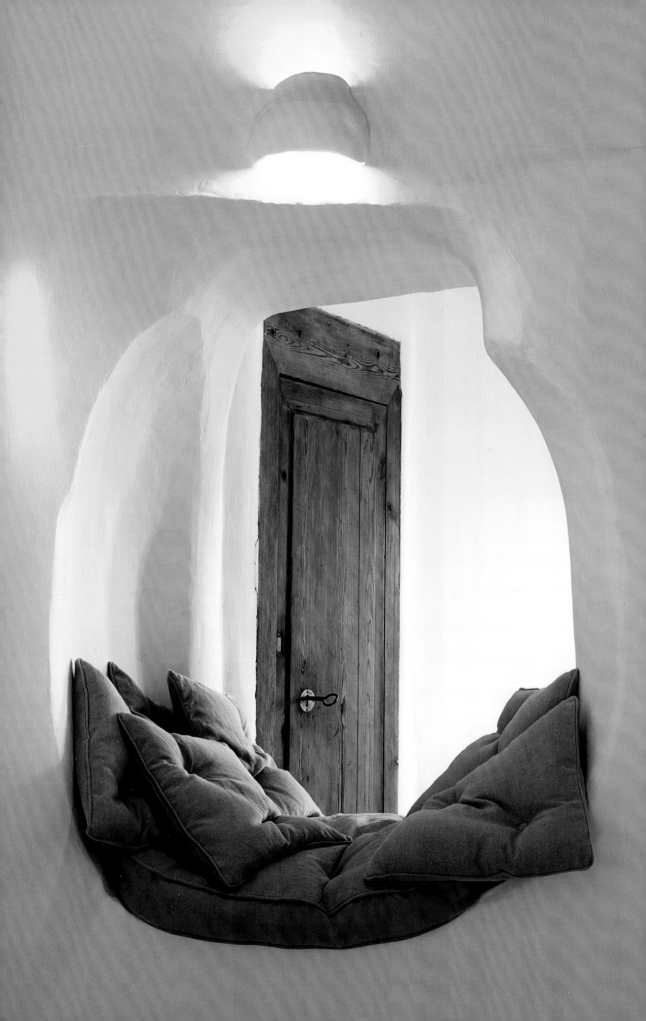

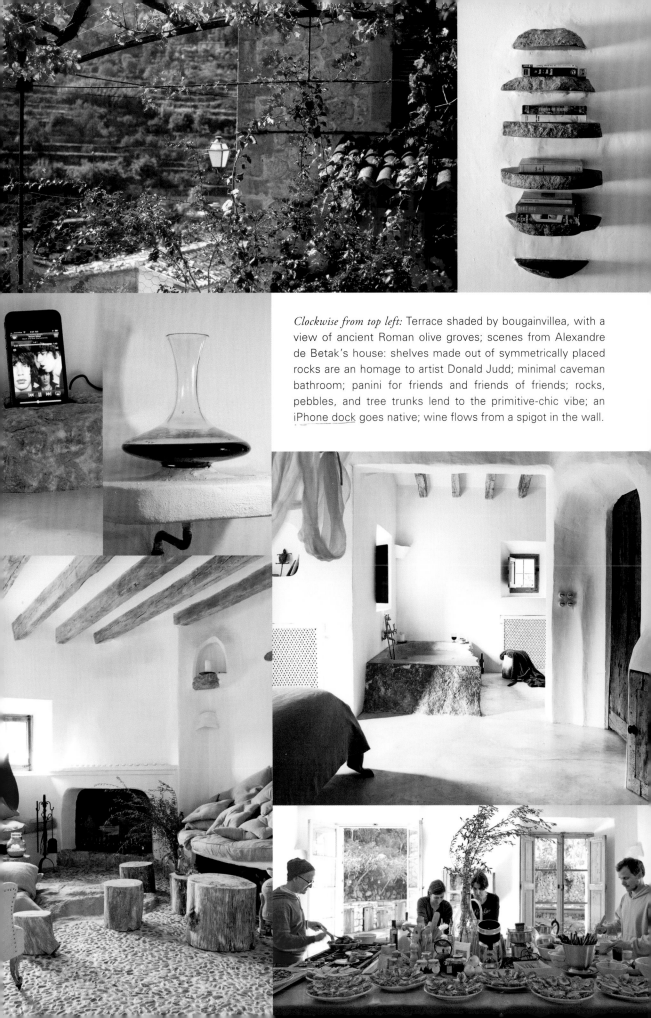

Clockwise from top left: Terrace shaded by bougainvillea, with a view of ancient Roman olive groves; scenes from Alexandre de Betak's house: shelves made out of symmetrically placed rocks are an homage to artist Donald Judd; minimal caveman bathroom; panini for friends and friends of friends; rocks, pebbles, and tree trunks lend to the primitive-chic vibe; an iPhone dock goes native; wine flows from a spigot in the wall.

AEOLIAN ISLANDS

"You know, when you're on those islands you're there for keeps."
STEVEN MCQUEEN in *Papillon*

S ome of the world's most popular islands—Spain's Formentera, La Digue in the Seychelles, and the entire mega isle of Australia—were once colonies where authoritarian regimes and all-powerful monarchies stashed deviants and undesirables. Consider poor Steve McQueen and Dustin Hoffman in the 1973 film *Papillon:* They are prisoners of the French empire, sweaty and sunburned, trying to escape the shores of French Guiana's Devil's Island by stringing coconuts together into a makeshift raft.

But somewhere between Napoleon's exiles and Trip Advisor, these hostile and remote slabs of scrub morphed from prisons into paradise. They were recognized as the dwindling resources they are: some of the last remaining corners of the planet free of

A view of one's own.

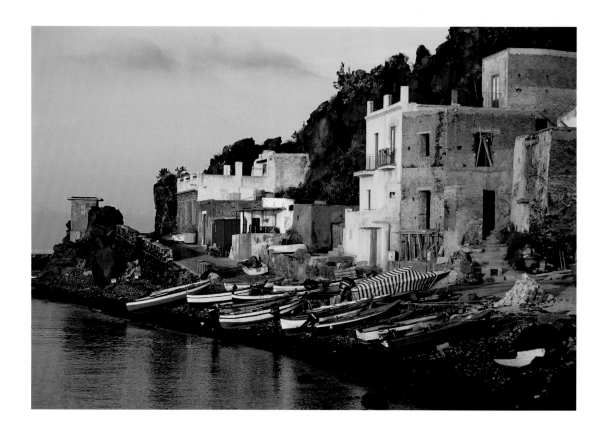

overdevelopment, and thus the Holy Grail for gypsetters. These days Steve McQueen and his pal Dustin would be better off throwing on a caftan, slathering on some sunblock, inviting some friends over, and staying put.

Which brings us to the headache-to-reach Aeolian Islands, a volcanic archipelago north of Sicily that juts out of the Tyrrhenian Sea—a Middle Earth mix of surreal rockscapes, hot thermal water spouts, and black lava beaches.

For decades the seven inhabitable islands (Lipari, the largest, was actually a penal colony) were undesirable no-man's-lands with populations whittled down by plague and starvation. On Stromboli an overzealous volcano was constantly hurling molten lava down on the villagers—at least the few brave ones who stuck around or had nowhere else to go. (Check out Roberto Rossellini's 1950 creepy classic, *Stromboli*.) Not to mention the incessant wind, which can be just as menacing as the lava. Just ask poor Odysseus, who sailed through the Aeolians on the way home to Ithaca. Aeolus, the mischievous ruler of the winds in Greek mythology—and the chain's namesake—blew *The Odyssey*'s hero back to the craggy shores of the islands whenever he tried to leave. Know the feeling?

Of course, when summer rolls around, all is balmy and calm. And that's when the gypsetters gather. They head to the smaller, more rustic islands: Stromboli, Panarea, Filicudi, and Alicudi. The British contemporary artist Martin Creed—who has wild curly hair, often wears a wrinkled suit, and fronts an experimental rock band—keeps a home on Alicudi, a rock protruding violently out

Above: The rugged port of Alicudi—not a T-shirt shop in sight.
Following pages: Twilight at Lisca Bianca, the iconic rock where Michelangelo Antonioni filmed parts of his classic *L'Avventura* (1960).

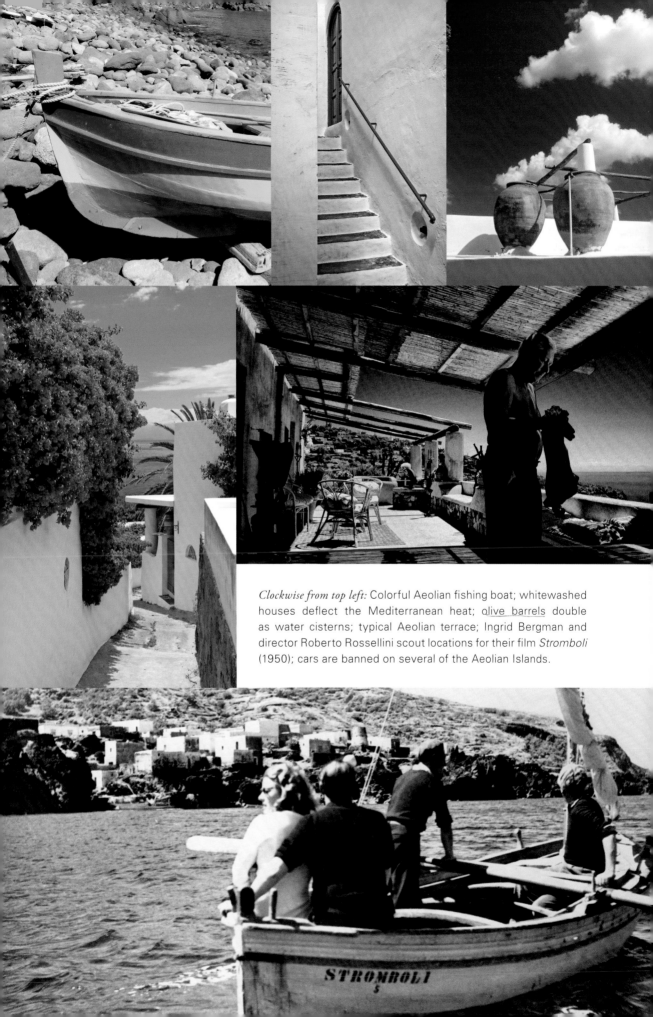

Clockwise from top left: Colorful Aeolian fishing boat; whitewashed houses deflect the Mediterranean heat; olive barrels double as water cisterns; typical Aeolian terrace; Ingrid Bergman and director Roberto Rossellini scout locations for their film *Stromboli* (1950); cars are banned on several of the Aeolian Islands.

STROMBOLI

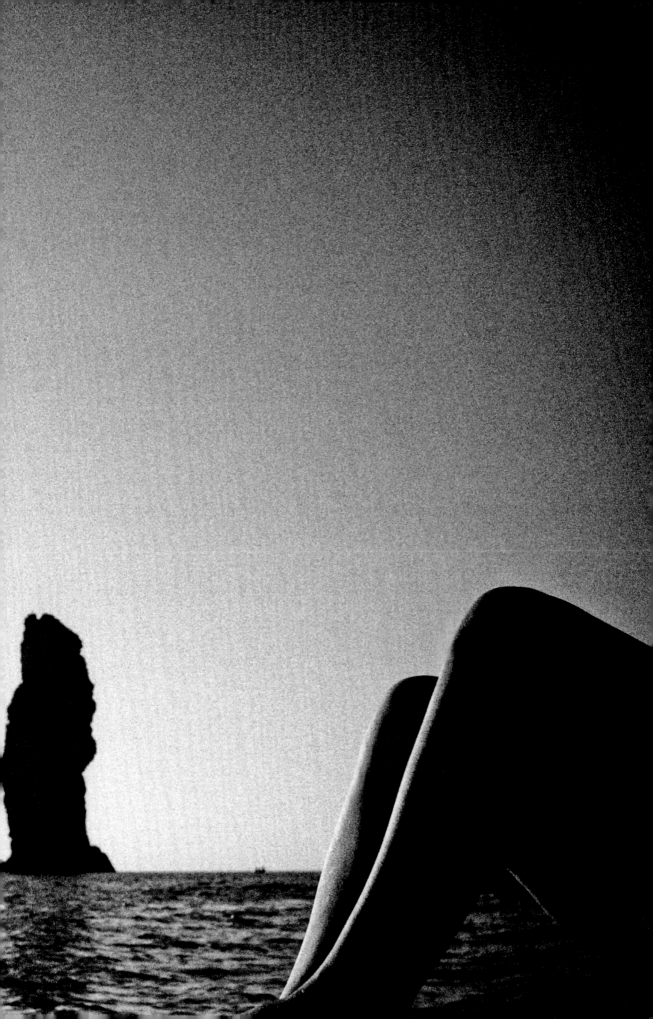

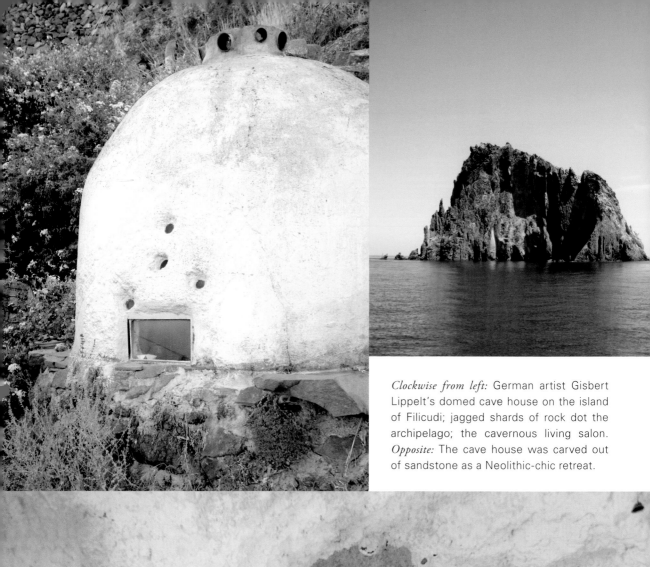

Clockwise from left: German artist Gisbert Lippelt's domed cave house on the island of Filicudi; jagged shards of rock dot the archipelago; the cavernous living salon. *Opposite:* The cave house was carved out of sandstone as a Neolithic-chic retreat.

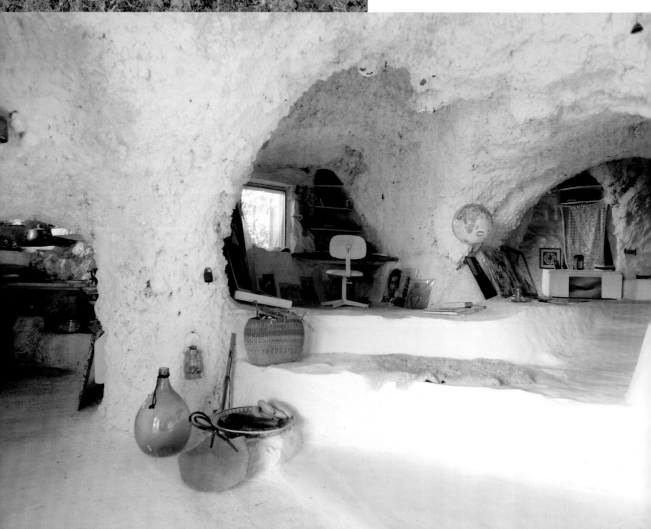

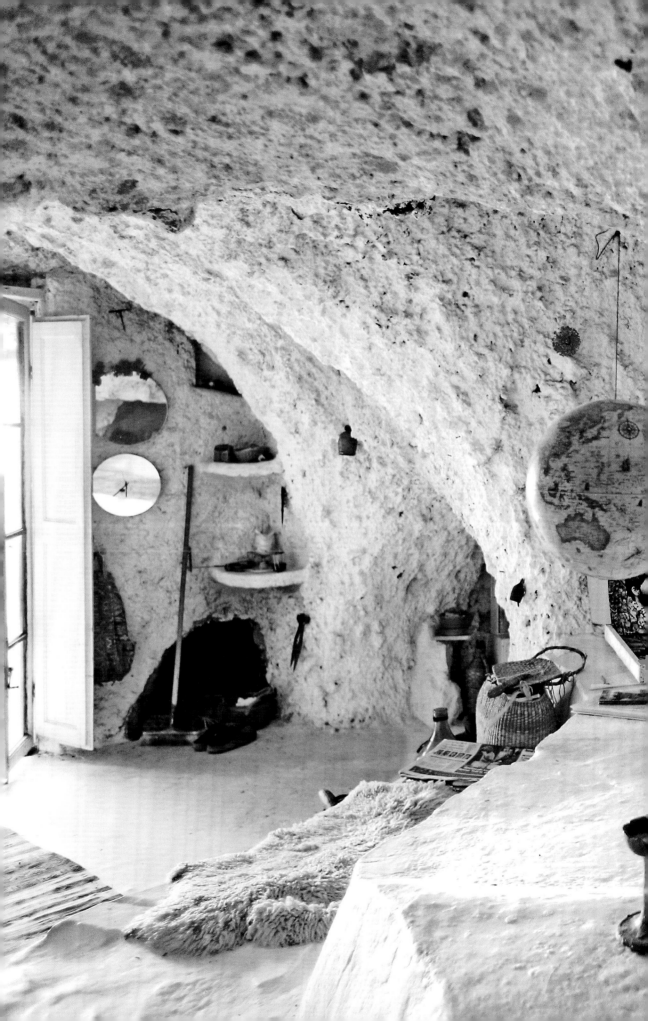

of the sea west of the other islands. Donkeys are the only means of transportation, and one must endure hundreds of steep cliffside steps to get anywhere, which, of course, is all part of all part of Alicudi's charm. "From London it's easier and quicker to get to Australia," Martin likes to say.

Filicudi is the Aeolian equivalent to gritty artist enclaves like LA's Silver Lake, New York's Bushwick, or East London. Except, of course, it's surrounded by cacti and the Tyrrhenian instead of asphalt and garbage. One instantly longs for a cozy couch and abundant shade when visiting Filicudi's sparse harbor. The sunlight is intense and rocks are scattered about the parched earth. At Da Nino sul Mare, the island's main café, construction workers and fishermen gather under the outdoor awning and shout to one another; it's like a scene from some black-and-white Italian film. Ettore Sottsass, the groovy Italian founder of the 1980s Memphis Group movement, lived here before he died in 2007 at the age of ninety. Creative types like the artist Maurizio Cattelan, architect Massimiliano Fuksas, and Milanese art dealer Sergio Casoli decompress up in the hills among caper bushes and ferns. Filicudi even has its own art fair, Biennale d'Arte di Filicudi, which is possibly the smallest biennial in the world. There's certainly no palazzo party-hopping in polished teak *motoscafos* here. Rather, the event takes place in the home studio of the Swiss artist Jacques Basler. Revelers, local poets, potters, and artists knock back vast quantities of the native malvasia wine before stumbling over to La Sirena, a seafood restaurant in the old fisherman's port of Pecorini. Who could ask for a better night out?

"Artists like the Aeolians because it's hard here," explains Marina Abramović, a performance artist born in Serbia who bought a house on Stromboli in the town of San Vincenzo. The island became her real-life studio, where she produced photo series of herself licking molten rocks and hiking up the volcano nude. "It's a place of intense power and energy," Marina says. So intense, in fact, that she sold her house and is now based in New York.

Panarea, with its narrow cobblestone footpaths overgrown with frangipani and wild cacti, is the chicest of the islands. Via Vincenzella is a tiny lane where elegant Italian families live incognito; Bulgaris, Viscontis, and Borgheses hide out inside little whitewashed cottages. The artist Ramuntcho Matta has a breathtaking bohemian compound overlooking Calcara Beach, on the far north side of the island. His father, the late Chilean surrealist painter Roberto Matta, arrived here by chance in 1954 aboard a small boat with a case of champagne. Matta still owns the house his father bought for $200, and it's a favorite hangout for visiting gypsetters. In 1960 Michelangelo Antonioni filmed parts of his classic *L'Avventura* on Lisca Bianca, a jagged rock just offshore.

But it was the opening of the Hotel Raya in the 1960s that truly transformed Panarea into an aristo-bohemian retreat. It's the opposite of a design hotel, as nature—and not an architect—

Following pages: Going native at a natural volcanic mud bath on Vulcano Island; bathers soak in the healing waters of a pumice quarry on Lipari.

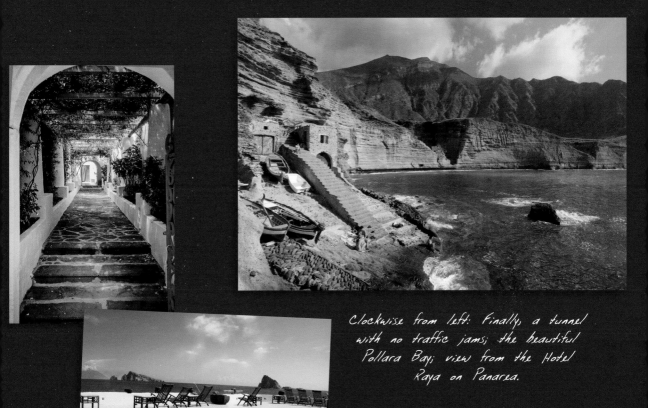

Clockwise from left: Finally, a tunnel
with no traffic jams; the beautiful
Pollara Bay; view from the Hotel
Raya on Panarea.

House on the island of Alicudi.

Above, top to bottom: Party
girls; Alessandra Borghese,
Francesca Thyssen, and Gloria
Von Thurn dining on Panarea.
Right: The boys of summer.

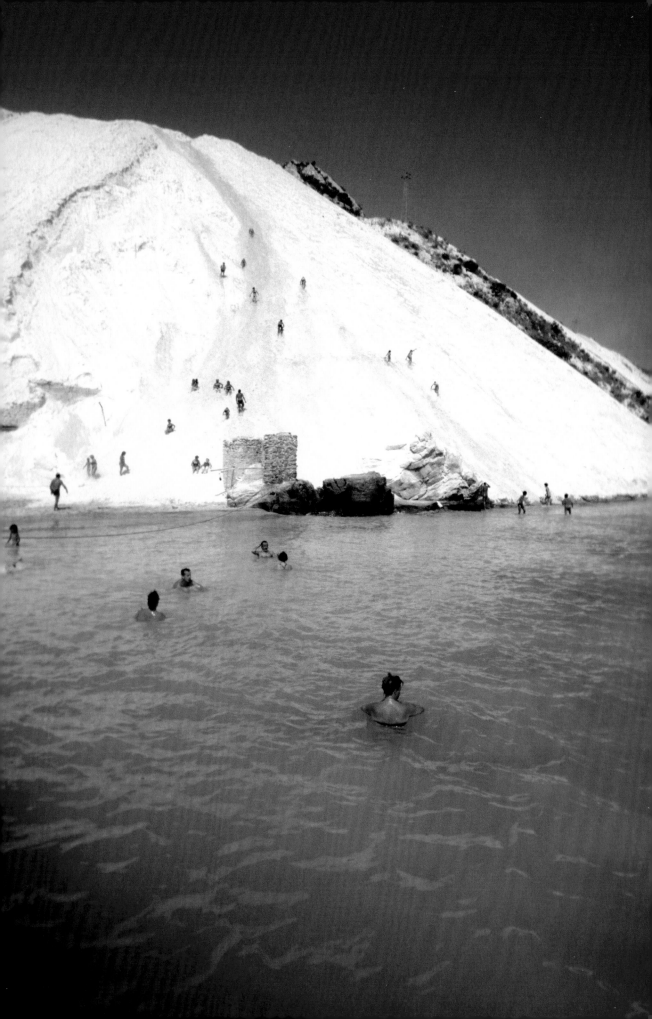

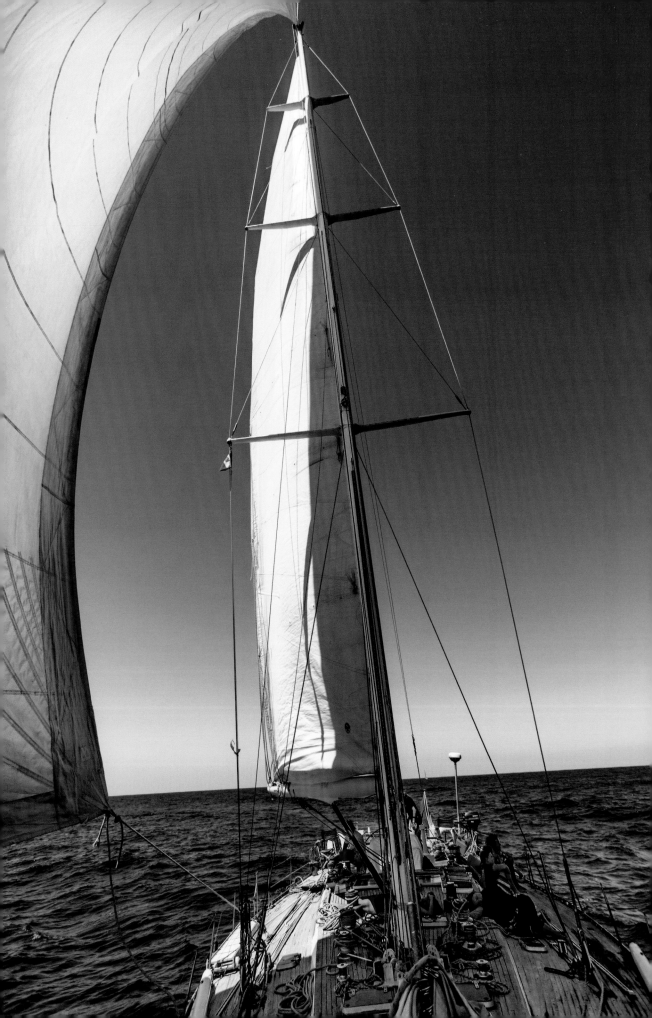

dictated the plans: The Raya was haphazardly built into the terraced cliffs by the harbor. Rocks that were in the way became part of the decor, and guests gather in the morning over frothy cappuccinos inside a cave repurposed as a café. It's one of my favorite hotels in the world.

The owners, artists Myriam Beltrami and the late Paolo Tilche, built the place as a guesthouse for their friends next to a fisherman's cottage they called home, and it grew from there. Myriam is a total hippie, spending winters in Indonesia and insisting that the Raya waitstaff go barefoot. She's purposefully maintained the hotel's two-star rating by refusing to add flat-screen televisions and bidets, which I think was a very gypset thing to do. "It's nothing," Myriam says of her perennially overbooked hotel. "Just a place where nature lovers can find peace and have time for themselves. It's not a place to visit if one doesn't like walking, or if one is looking for a hotel that works like a Swiss clock." In the 1990s, Myriam and Paolo had the idea of opening a disco on the terrace overlooking the sea. Much to Myriam's annoyance, the place has become the hottest scene going in the Mediterranean, with Madonna, Domenico Dolce and Stefano Gabbana, and Leonardo DiCaprio all popping champagne on the pink daybeds. Myriam tried to close the place a few years ago, but everyone complained, so she relented.

Still, the island's summers can seem like a turf war between the jet set and gypset. Aleksandra Mir, an artist who frequents Panarea, remembers when she saw a luxury yacht crash into a heap of volcanic rocks—one of her favorite moments. "It seemed to happen in slow motion," she says, "as the high-tech navigational gear on the boat was overtaken by the slow force of the wave. Hearing and seeing white fiberglass being crushed by the silent volcano was like experiencing the most masterful of sculptures."

Cruising on the Tyrrhenian Sea.

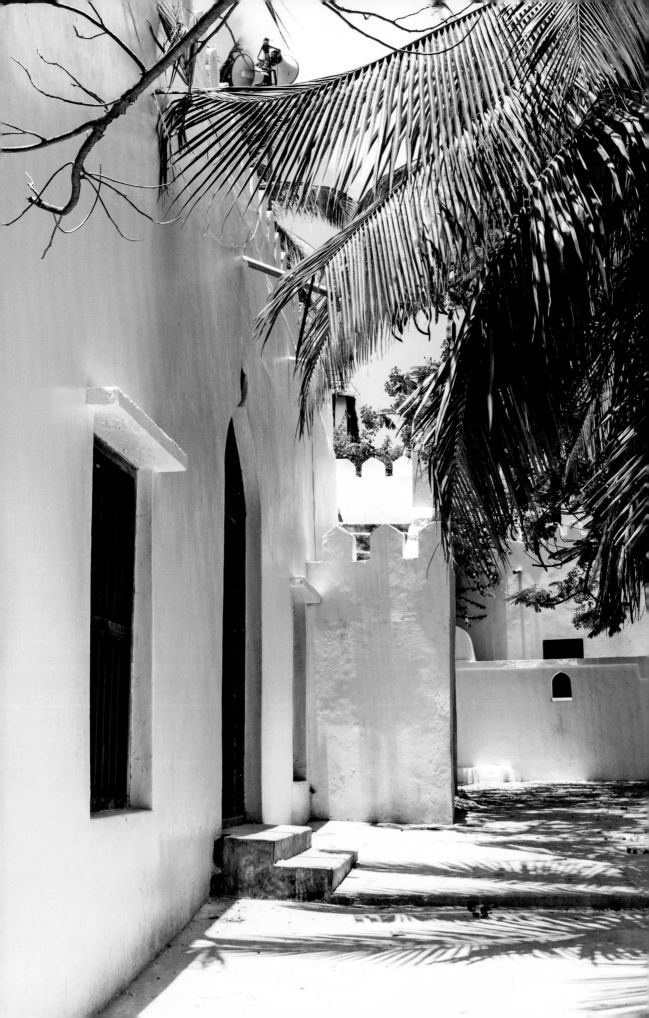

LAMU

"The good thing about Africa is that you can escape forever.
You can do what you want, without someone looking over your shoulder"
PETER BEARD

In the fourteenth century, Arab traders settled this sunbaked island off Kenya's Swahili coast as a trading port, and not much has changed since then. Camels still haul cargo sacks through the narrow streets littered with donkey dung and open sewers. Women still walk around in the blazing sun in black robes that reveal only a pair of almond-shaped eyes. Local men wear full djellabas and religious hats. Calls to prayer ring out from the mosques several times a day. Lamu is one of those unspoiled, premodern places travelers talk about with hushed excitement. Elusive as it is chic, Lamu is by all accounts a must-stop on the gypset map. A decade ago, UNESCO pronounced the island a World Heritage site, but slumming aristocrats and mendicant poets have been quietly making the pilgrimage for the better part of a century. Lamu is the forwarding address for a motley mix of escapists and wanderers.

It took me a few years to get there, but I finally arrived one spring day aboard a rickety Air Kenya plane that landed on a dirt runway. The makeshift tin shed nearby doubled as the airport. I was staying, along with my photographer friend Daniele, at the home of a British fashion-photography agent–turned-actress named Katy Barker, who had offered up her cottage during a drunken dinner the evening before in Nairobi. (Note to aspiring gypsetters everywhere: Drunken dinners are a great source of invitations.) The house didn't look like much from the outside—just a concrete wall with a small door, on a beach that reeked of fish. But Katy's home turned out to be a dreamy gypset palace: over-the-top in that way which exudes a confident sophistication. The sunken living room is flanked

A lazy afternoon in the village of Shela.

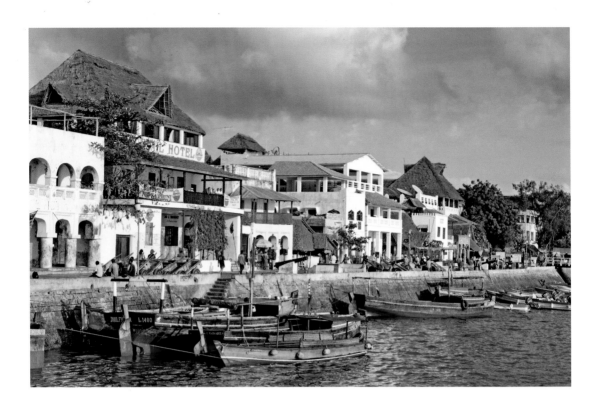

by a carved wooden horse; the bedrooms have breezy verandas instead of walls. Sitting on top of it all is a sprawling genie bottle of an observatory—perfect for yoga, cocktails, or watching the sunrise. The view from the top is all Omani turrets and Swahili pitched palm roofs, refracted through the high-fashion world that Katy inhabits. As we would soon learn, Lamu's best secrets are kept behind high walls and closed doors just like Katy's.

In public, cutoffs are tsk-tsk and alcohol is taboo. (I packed my usual minidresses and shorts—very problematic—until I discovered that colorful *kikoy* cloth, cheap and readily available in every market, makes for a groovy, last-minute cover-up.) Yet boozy decadence is very much alive and well in a Kate Moss–meets–Graham Greene sort of way. We found it in full bloom at the Peponi Hotel, a weathered colonial structure by the harbor.

The Peponi is a classic: It opened in the 1960s and still has one of the island's only bars. The name means "paradise" in Swahili, and the description fits. On any given night you might find Princess Caroline of Monaco (who keeps a house down the beach); trust-fund poets; pretty houseguests; French sailing families still salty from the row ashore; and shady international business types who like to pick up the tab. Dinner invitations are forthcoming, but last names are strictly off-limits. Vague and hard-to-place polyglot accents are the only form of background check here. Everyone is tipsy on the Peponi's signature cocktail, the Old Pal, delivered in icy batches to the table by barefoot waiters. Everything is made extra charming and mysterious by the scratchy soundtrack of jazz lilting from a sea-warped boom box.

Above: Lamu's waterfront with ancient cast-iron canons guarding the harbor.
Opposite: Water view of Lamu's polycultural architecture.
Pages 84–85: The Peponi Hotel, where the gypset gather at sundown.

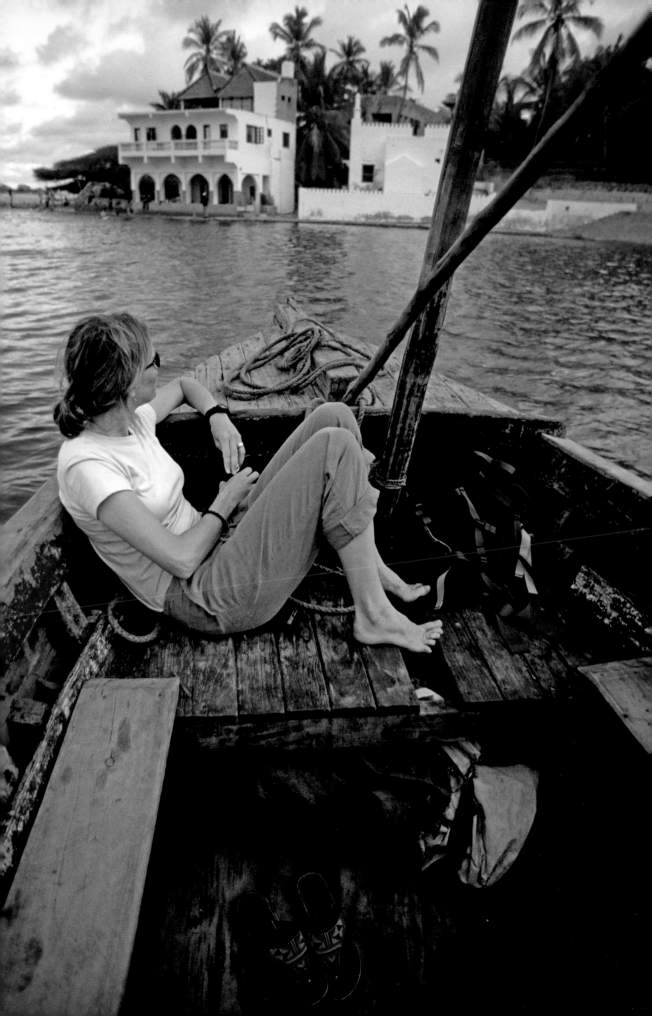

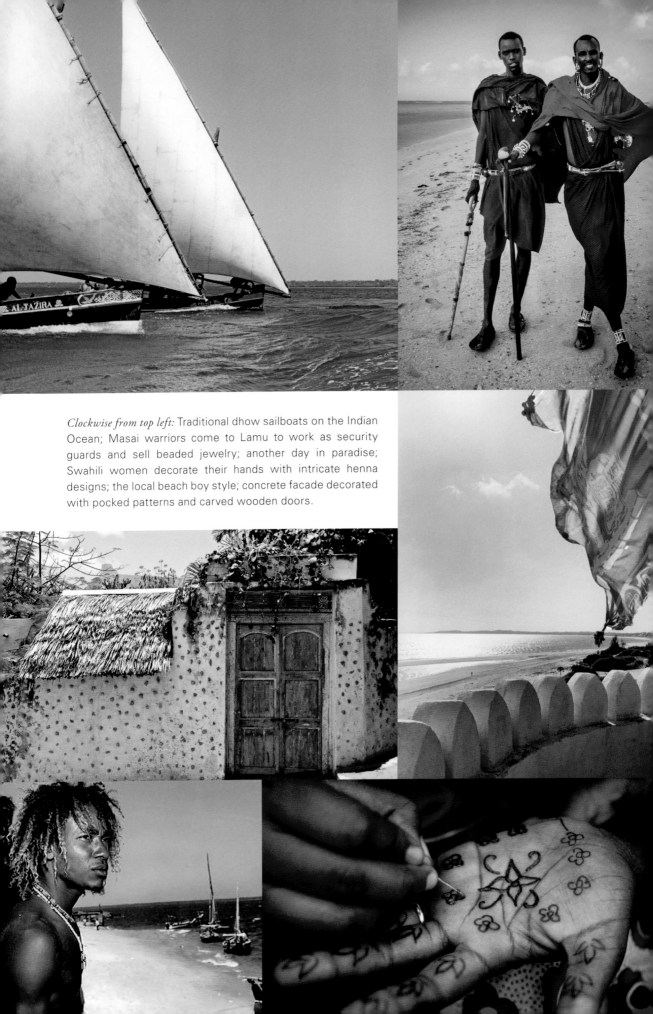

Clockwise from top left: Traditional dhow sailboats on the Indian Ocean; Masai warriors come to Lamu to work as security guards and sell beaded jewelry; another day in paradise; Swahili women decorate their hands with intricate henna designs; the local beach boy style; concrete facade decorated with pocked patterns and carved wooden doors.

During our evenings under the bougainvillea at the Peponi, Daniele and I did manage to discover the real names of a few of the characters. There was the Italian architect—rumored to have been a mercenary in the Congo—Claudio Modola. He lives nearby in a grass-and-bamboo hut with a giant clamshell for a sink. And Dodo Cunningham Reid, whose family was featured in *White Mischief*. She was staying with her Italian boyfriend, who owns casinos in Angola, at a modernist, concrete bunker on the dunes belonging to Hollywood film producers Chris and Roberta Hanley. I also bumped into my friends the Guillaumes, a French family that lives aboard their aluminum racing cruiser, *Kriss*, while migrating between St. Barths, Manhattan, and Bali.

"We were in Madagascar sailing to Cape Town against the wind," recalls Eve Guillaume, the family matriarch. "So we just followed the wind, and it brought us to Lamu." That was ten years ago, and now it's the family's winter home. "You feel far from civilization, but there are really interesting people," Eve explains. "Everyone is a bit crazy—in a good way."

One of the first stylish eccentrics and outcasts to come ashore in the 1950s was the wealthy Brit Latham Leslie-Moore, thought to be an illegitimate son of Edward VII. He converted to Islam and insisted that his servants carry him around town in a sedan chair. In the '80s the Euros arrived, but these days, thanks to Lamu's location and a serious lack of amenities, the crowd tends to be limited to those blessed with real determination and a very flexible schedule.

Not to mention a certain tolerance for risk. In recent years Somali pirates have stealthily made their way down the coast to strike the area's beachside resorts. After several incidents, the Kenyan government issued a travel advisory and beefed up security around Lamu. Whether it's safe to go or not is anyone's guess. The gypset geopolitical map is in constant flux. Alternative travelers are likely to tread in areas appealing precisely because of a certain authenticity and edginess.

Consider Afghanistan, Pakistan, and Iran in the 1960s, when thousands of hippies came through in robes and with prophet hairdos. "They played guitars and harmonicas, held hands, and organized card games," was how writer Paul Theroux described them in his 1975 book *The Great Railway Bazaar*. Today, of course, no traveler in their right mind would book that journey for rest and relaxation. But former no-go zones like Vietnam, Laos, or perhaps Colombia, on the other hand, seem wholly inviting. And so it goes with Lamu. Is it too dangerous? Or is it the perfect moment, since the uncertainty has diverted the onslaught of St. Tropez–type scenesters? I suppose it depends on whom you ask. Many of the Peponi regulars I spoke to said it's the opportune time to be there; it feels more like the quieter, old days before the word got out. The true talent of a gypsetter, after all, is timing. Knowing when to stay. When to leave. And when to return.

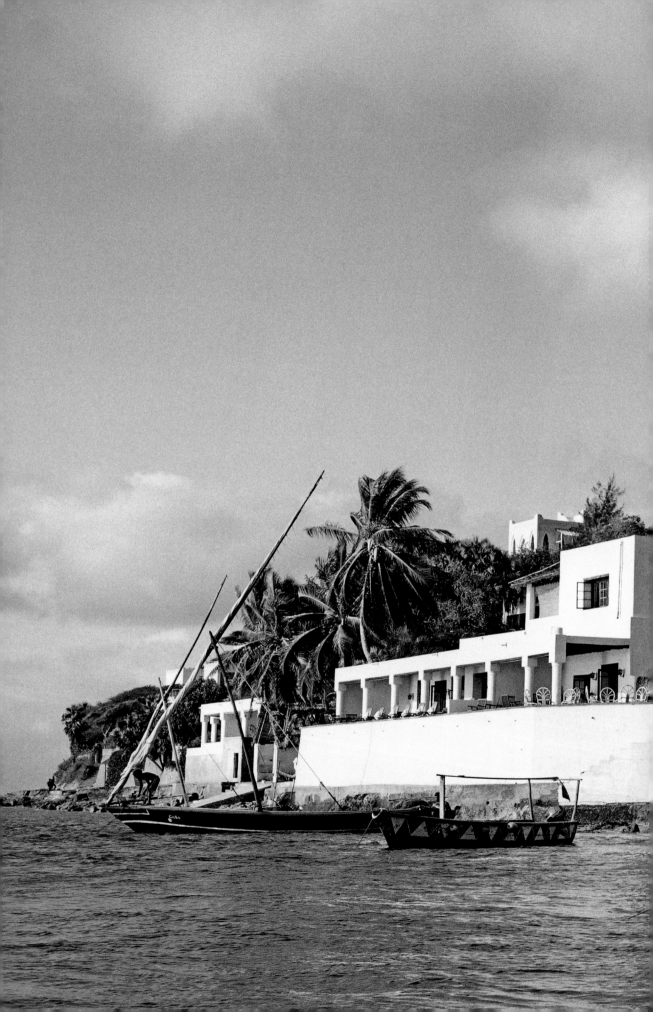

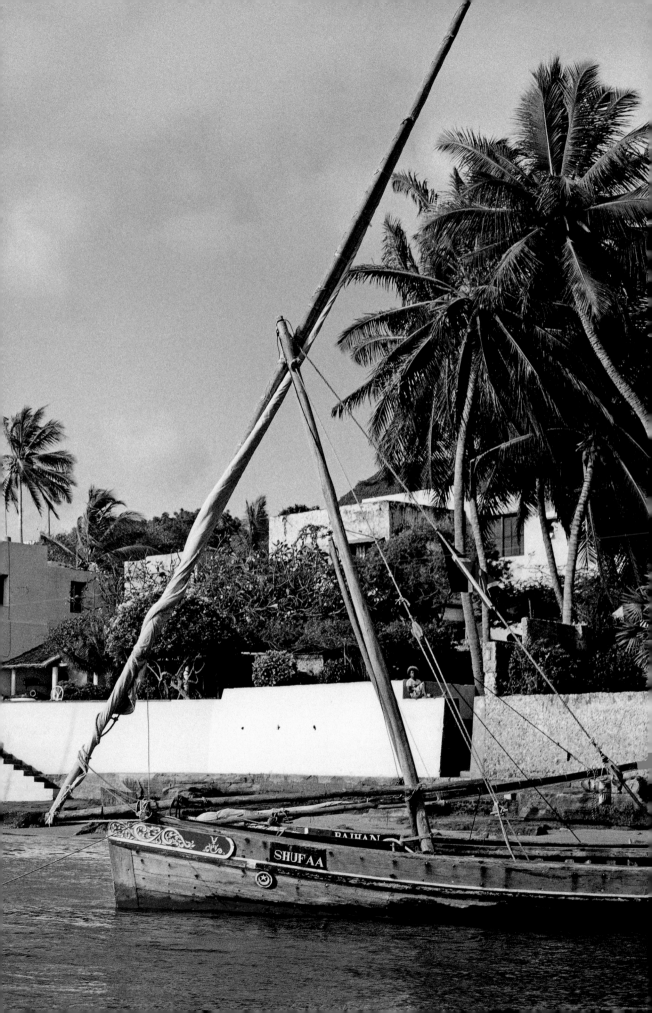

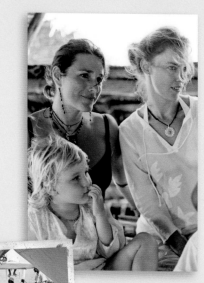

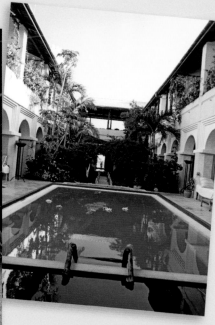

Above: Sandy Borman owns the chic Aman boutique where travelers stock up on the latest exotica.
Opposite: Italian architect Claudio Modola in casual Friday attire.

Above: Gypset jewelry and fashion designers, Carolyn Roumeguere and Elizabeth Warner.
Left: Picnics on dhow sailboats are a Lamu ritual.

Above: The pool at a luxe residential fort in Shela.
Left: Swahili guestroom.

"LAMU HAS ALWAYS BEEN ITS OWN LITTLE WORLD. AND THERE HAVE ALWAYS BEEN GLAMOROUS PEOPLE COMING HERE TOO. IT'S JUST THAT NOBODY USED TO NOTICE." —CAROLYN ROUMEGUERE, JEWELRY DESIGNER

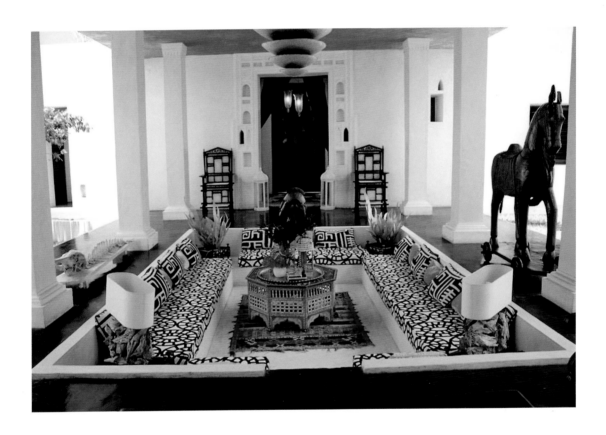

Above: The sunken living room in Katy Barker's Omani-Swahili refuge.
Opposite: Carolyn Roumeguere sells her wares at the Peponi Hotel.

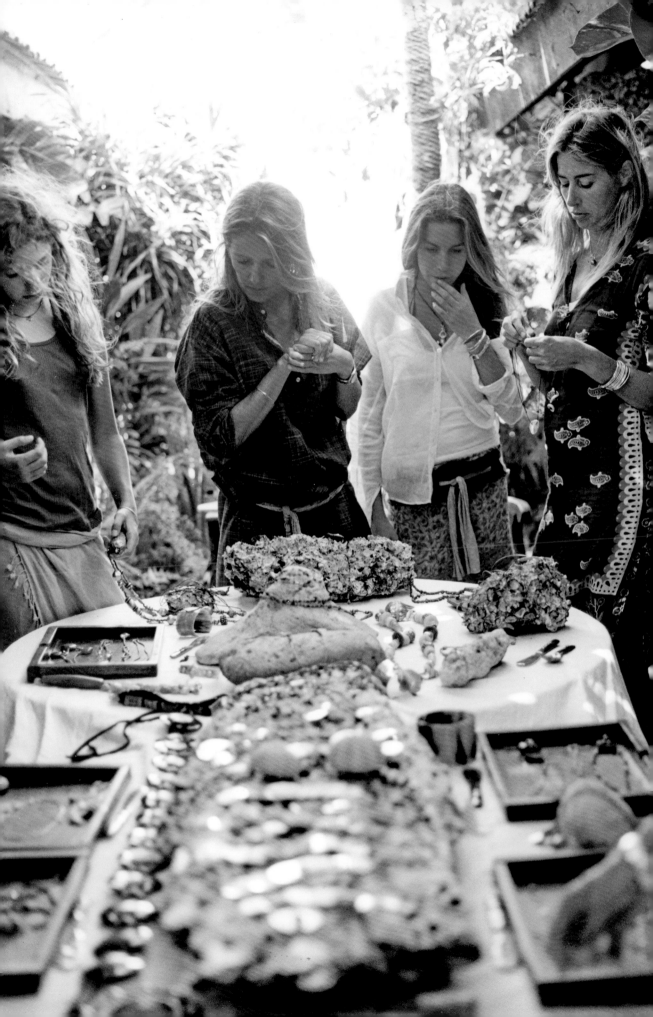

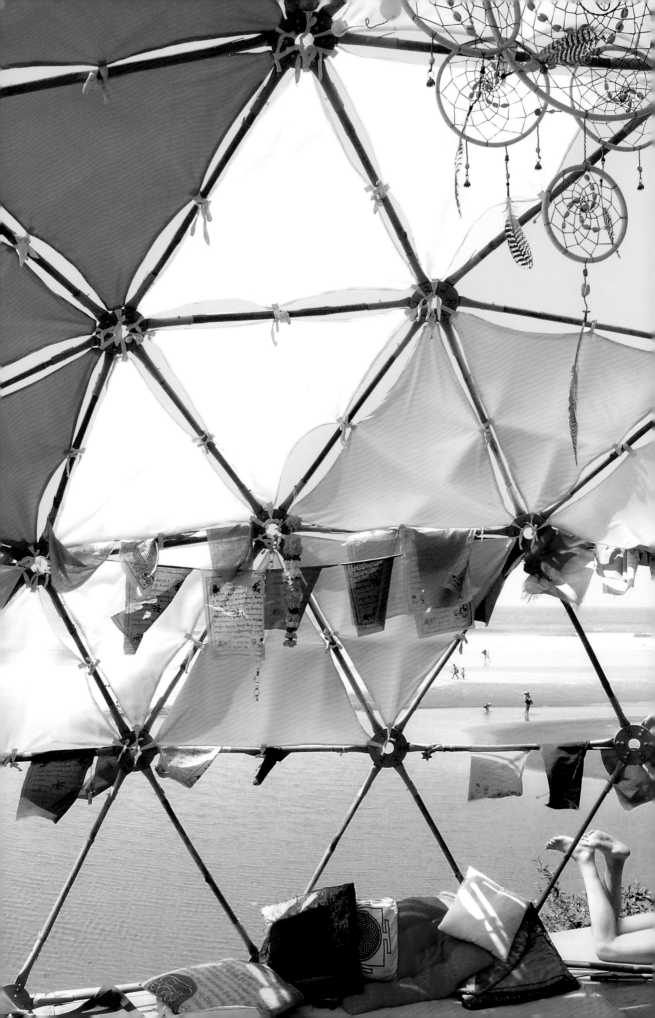

NORTH GOA

"Full moon is particularly a good time to be here. There's usually a mass party with psychedelics freely available and nude sunbathing is de rigeur."

LONELY PLANET *India*, 1987

Vintage guidebooks are fantastic barometers of social change. I'm sitting on the beach in Anjuna, in Goa, India twenty-five years after the above passage was written, trying to gauge the action in this legendary boho party mecca. In the 1960s, spiritual and drug-seeking hippies descended on this former Portuguese colony on India's southwest coast. Living on curry and chai, they slept in tree houses and experimented with gurus and grass. Few rules existed, and almost every budding rock star and hippie worth their weight in gold bangles came through, spreading a taste for sitars, embroidered tunics, and Osho far and wide. (Osho, or Bhagwan Shree Rajneesh, was an influential hippie guru, with hundreds of thousands of followers worldwide.)

What's interesting about the Goa chapter in my aged Lonely Planet is that while it thoroughly documents the fade-out of "old hippies," there is zilch about the then-emerging trance music scene—sometimes going off for three days at a pop during gatherings in the forest and on beaches. Was the travel writer simply lazy? Or was the scene still too underground? These are the questions playing in my mind as I try to figure out what to do that night. If history repeats itself, there has to be something going on somewhere. I just have to tune in to the right frequency to find it.

I discover that the authorities are enforcing an inconvenient new anti-nightlife ordinance: All restaurants and bars have to close by 10 p.m. Of course the law is mostly honored with baksheesh—the Indian term for a bribe—or extreme measures of stealth. The closest I get to a good party that night is at Thalassa, an outdoor Greek restaurant overlooking Little Vagator Beach. But the vibe dims after all the

Dome adorned with a dream catcher and a sunbather on a breezy hill by Mandrem Beach.

lights are turned off, in accordance with the 10 p.m. law. Huddling together with some new friends by the flicker of a single candle, I realize that it would be easier to find a party on the streets of Iran.

The dance music scene still exists. Promoters simply schedule events to start at midday, which, in my opinion, is the worst time to experience a set of pounding trance. A few nightclubs do manage to stay open late, like Shiva Valley and Curlie's on the touristy part of Anjuna beach. But they are bars with neon beer signs, similar to what you can find in any spring-break town. I want an experience like the one described in the 1987 Lonely Planet: something psychedelic and possibly nude. And from the looks of the other freaky travelers zooming past on mopeds and wearing fur minis, fluorescent ascots, and knee-high gladiator sandals, so do they. "Instead of partying, they go jogging in the morning!" This is the view of Chris, a Brit who opened the Ashiyana yoga retreat center in the northern town of Mandrem. "The future is yoga!" But of course Chris would say that.

When beach towns get played out, the cool people quietly sneak up or down the coast. In Goa the center of the gypset scene has shifted north past Calangute and Baga (now piled up with chain hotels, traffic, and strip malls) as well as commoditized Anjuna to the windswept beaches of Morjim, Ashvem, and Mandrem—areas not even on the map in my 1987 guidebook. I take this as a sign of progress—in the sense that something new might be happening, not just a rehash of the old era.

Ashvem Beach is where all those moped-riding, neo-hippie fashionistas were headed. Jade Jagger, who re-pioneered the north of Ibiza in the 1990s, has even set up shop here. She has a low-key compound—a series of small cottages that she rents out to friends and friends of friends. Her boutique on the beach is a simple shack with chill-out mats and a small bamboo bar. La Plage, a restaurant run by three French expats tucked into the palm trees nearby, is like a daytime Studio 54. On Sunday afternoons in the high season (December through February), the international crowd parades around in beach exotica. Indian supermodels rub bare shoulders with French sun worshipers, and everyone covers up with sarongs wound around amazing bodies. At the big table in the corner, a group of dreadlocked travelers in homemade couture have come down from their tree houses in Arambol, even farther up the coast. "It's for a new generation that travels a lot and has all the right references," says Serge Lazano, one of La Plage's owners. Prices and pretension are kept down to guarantee an interesting mix. "Nobody here wants marble or air-conditioning. It's a redefining of formality."

My favorite of the new beach spots is Mandrem. I stayed at a very gypset hotel there called Elsewhere. Finding it is hard. You have to walk down an alleyway and past laundry lines and junky backyards. Then you cross a narrow footbridge over a river that leads to a Portuguese colonial estate with several traditional cottages on wild land. Denzil Sequeira, a fashion photographer from Bombay and an avid conservationist, inherited the property from his family and gave it a hands-off renovation. Like Jade

Following pages: Boho-luxe suite at Yogamagic with a Rajasthani-style tent.

92

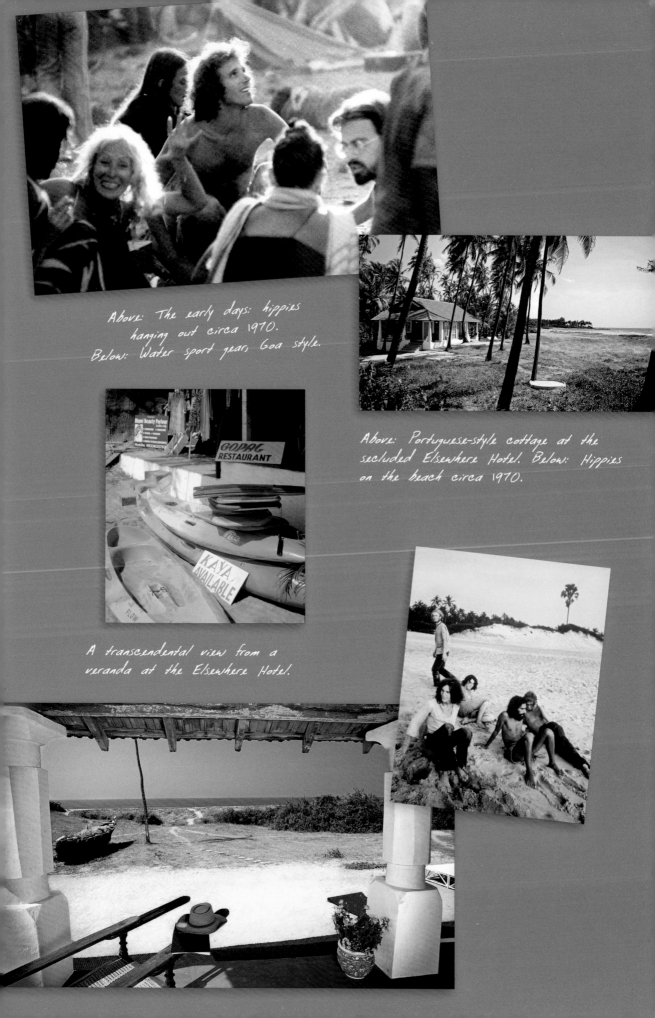

Above: The early days: hippies
hanging out circa 1970.
Below: Water sport gear, Goa style.

Above: Portuguese-style cottage at the
secluded Elsewhere Hotel. Below: Hippies
on the beach circa 1970.

A transcendental view from a
veranda at the Elsewhere Hotel.

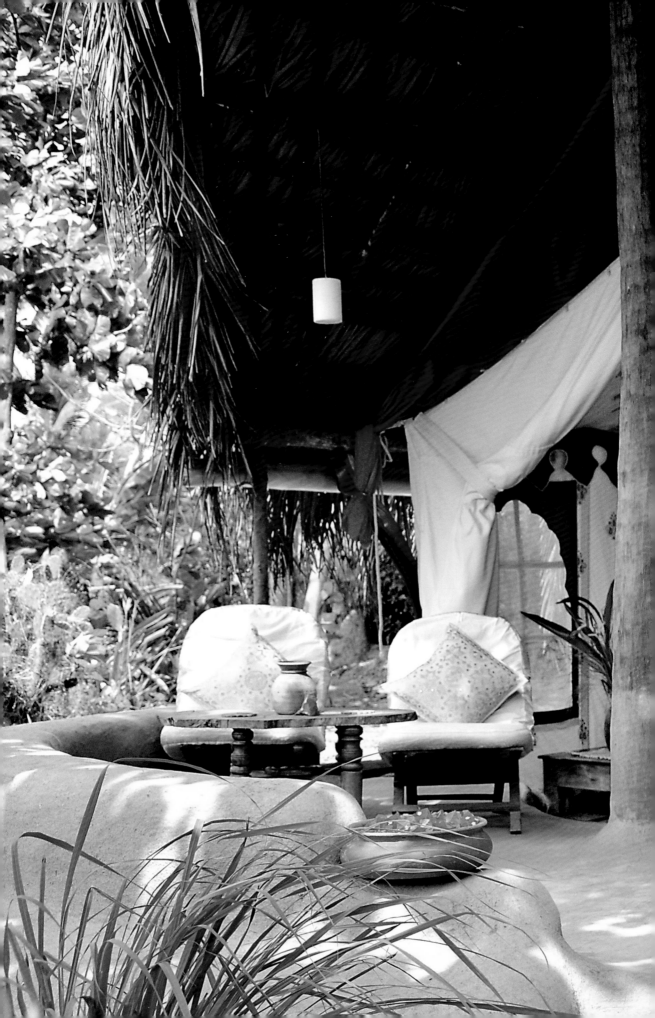

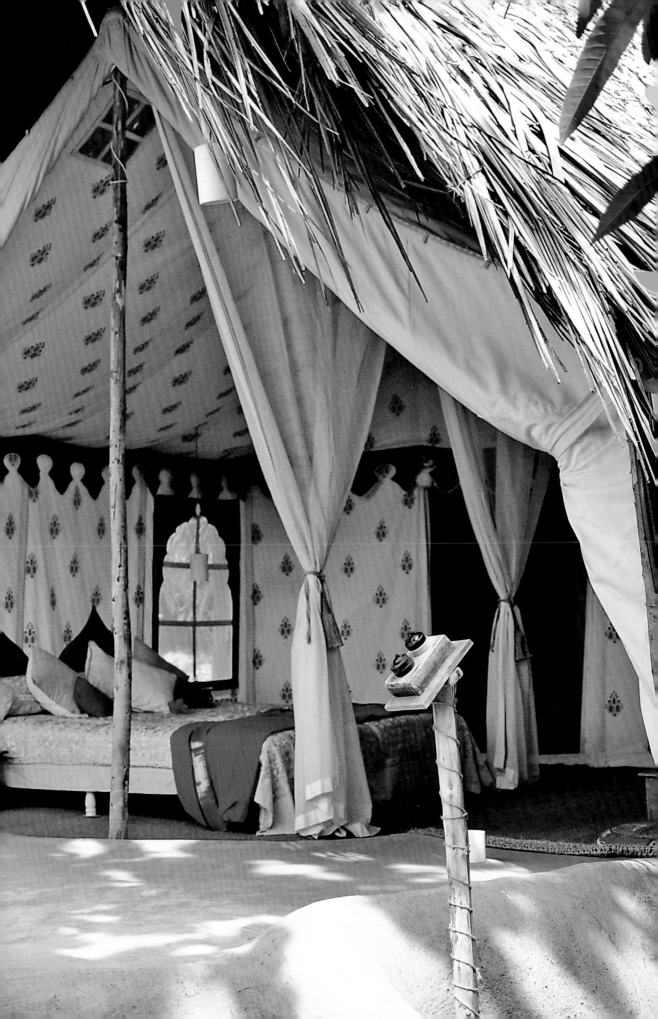

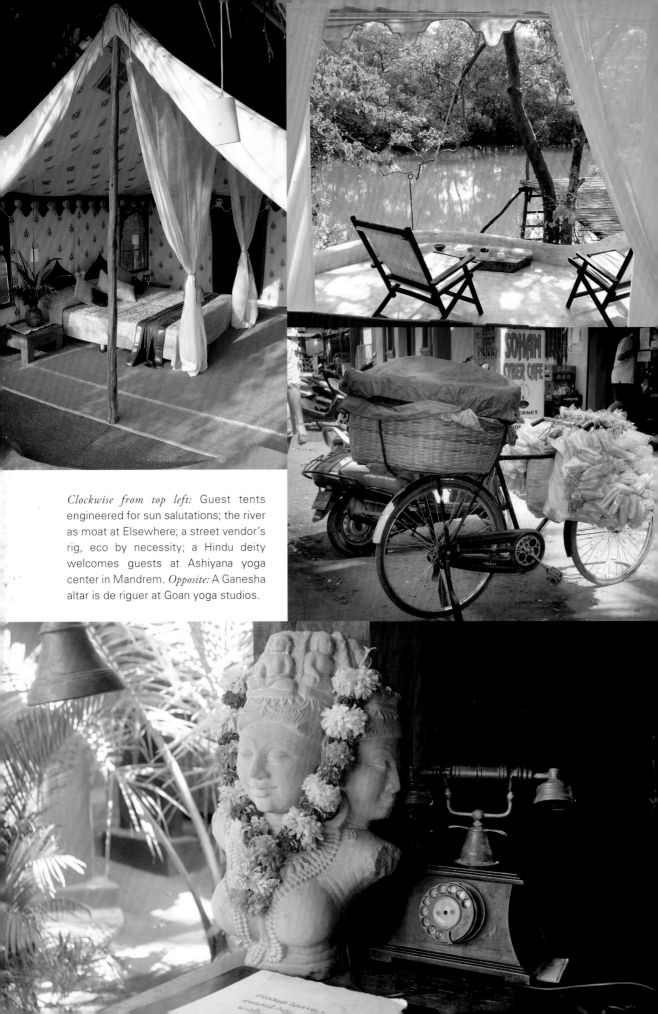

Clockwise from top left: Guest tents engineered for sun salutations; the river as moat at Elsewhere; a street vendor's rig, eco by necessity; a Hindu deity welcomes guests at Ashiyana yoga center in Mandrem. *Opposite:* A Ganesha altar is de riguer at Goan yoga studios.

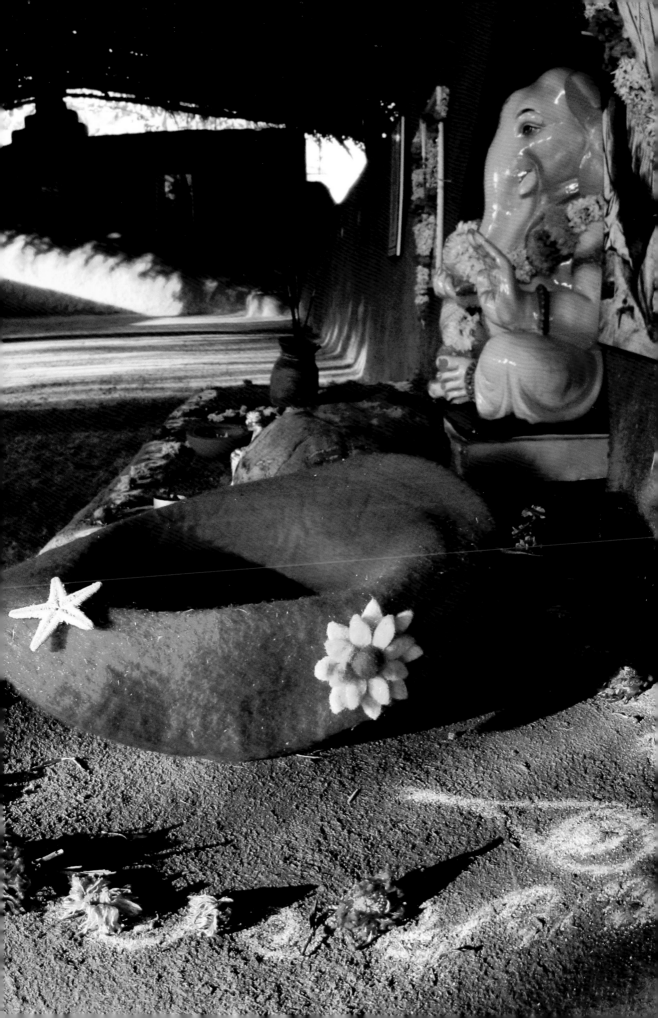

Jagger's boutique and La Plage, Elsewhere is all about the luxury of reduction, letting nature take over as the maximal, baroque element—it's just open beaches, grassy dunes, and big skies. (And sometimes Brad Pitt, Angelina Jolie, and Salman Rushdie, too.)

Mandrem's beach looks like all the others, except there are fewer restaurants, big hotels, and aggressive vendors trying to sell you an earwax cleaning and sarongs. Nude sunbathers are left in peace. Sinewy yogis do acrobatic sun salutations on the sand, and a few free spirits can even be seen dancing around in the waves to their own tune.

Fashion design seems to be the way many gypsetters fund their beach-hopping lifestyle. Not surprisingly, a neo-hippie look that references seasonal traveling, late nights, and glamping (glam camping) has emerged in North Goa. The best place to glimpse "the new look" is the Saturday night market in Anjuna—a sort of living runway where young traveler-designers sell their wares in booths. Khristina, a lithe Russian girl from Siberia, had the sexy, tribal, hunter-gatherer style down pat. She was wearing an animal pelt over a torn leather miniskirt and on top a ruffled Victorian blouse under a cropped Mongolian shearling vest. Ankle-high flat leather boots—which protect from moped rash and the dusty red Goan dirt—are the footwear of choice. When not in India, Khristina travels between Bali, Thailand, and her home in Siberia, helping her friends sell clothes in various street markets. Sales and marketing, she calls it. Jonny Jade, a British fashion designer who has a shop called Dust on Ashvem Beach, describes the style: "It's sort of gypsy meets tribal."

Jonny's friend, Vicky, another Brit who plays in a traveling band called Storia, invites me to a party in Arambol, a hippie stronghold that's a thirty-minute cab ride north of Mandrem. "It will be a special night there," she assures me. Not that I needed much assurance. Arambol reminds me a bit of Burning Man but with a better climate. No electricity or neighbors likely to complain about anything. Most of the inhabitants live in tree houses, and some modify their ears to look like elves. Guest huts—which rent for less than ten dollars a day—have names like Chill Pod and Om Ganesh.

Arambol is said to possess one of the most beautiful beaches in North Goa, but when I arrive, past a surreal procession of Hindus dancing in the streets, it's dark. (I've also heard Arambol is better experienced at night, when all the detritus of daily life recedes into the shadows.) The hum of generators fills the evening air, and renegade bars and clubs are lit up with colored lights like trippy stage sets. We follow the traces of music—not hard-core trance, but a more melodic dance hybrid—down a sand path and find hundreds of nubile partiers dressed in the Goa wood-nymph-tribal style hanging out and smoking charas (Indian hash). There is a sort of amphitheater set up with giant animal totems and effigy heads made of twigs and cloth. To enter, you have to walk through a neon-painted tepee. Wherever the night would lead me now matters little. I am just happy to have found the party.

Opposite: Sunday afternoon at La Plage restaurant, Ashvem Beach.
Following pages: Quentin Staes-Polet and Tinu Verghis, an Indian model, at their home in Goa; the sarong set: Sunday afternoon at La Plage.

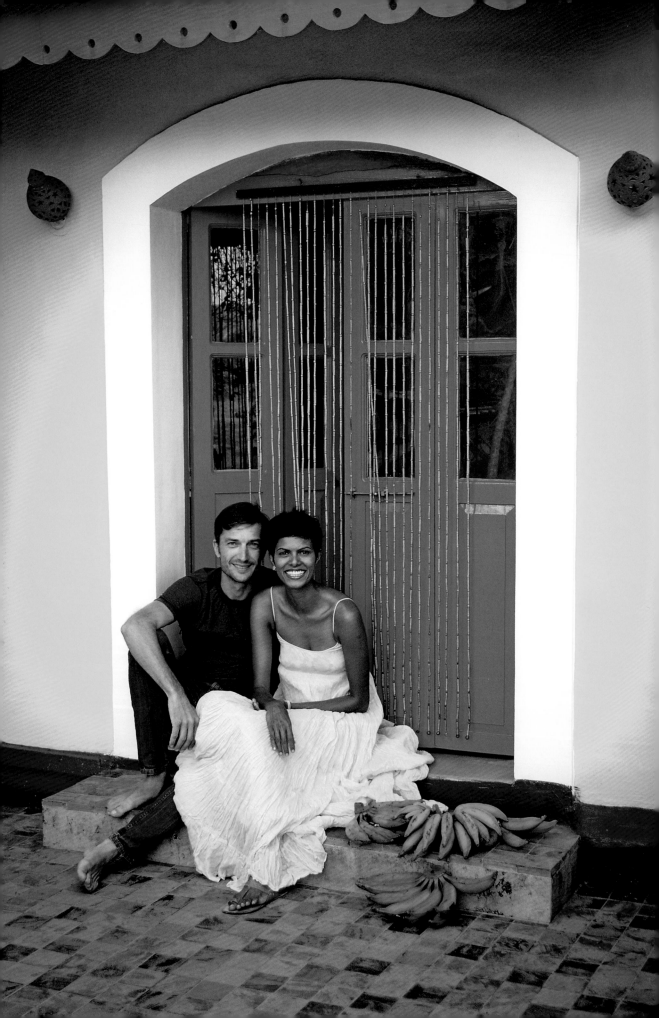

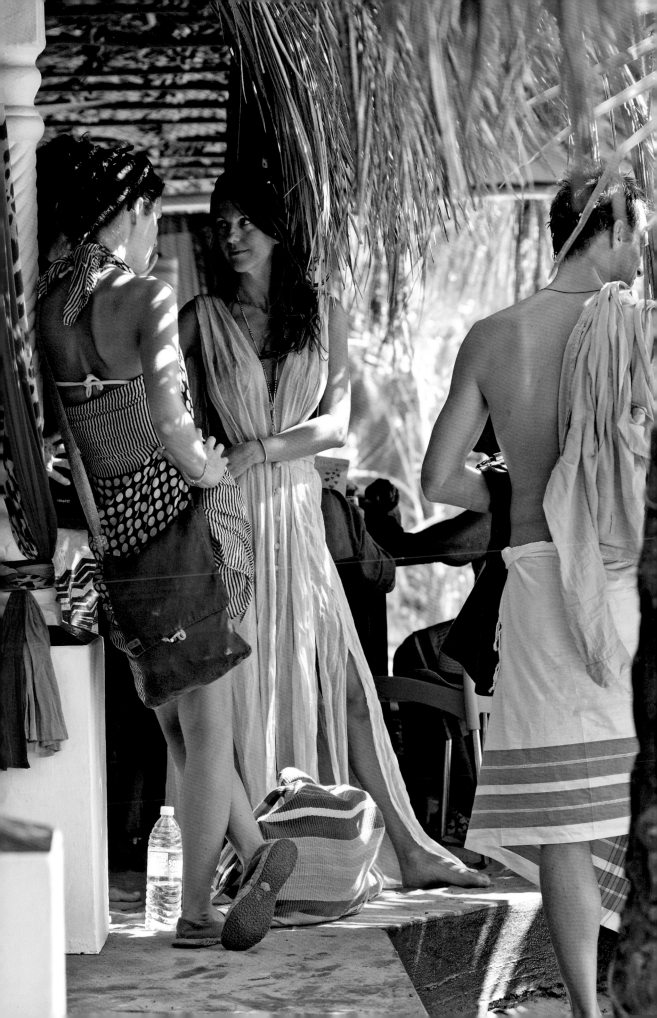

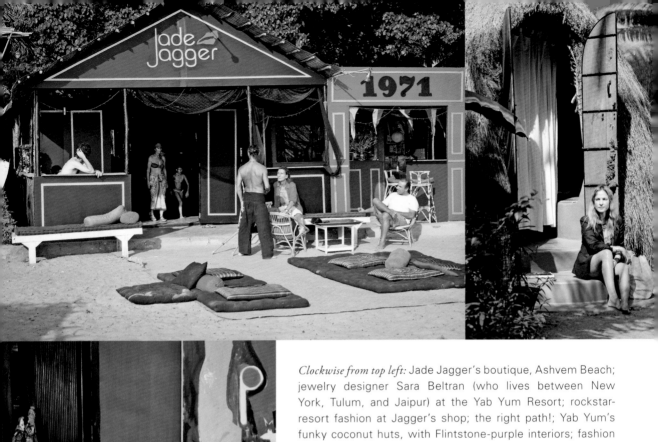

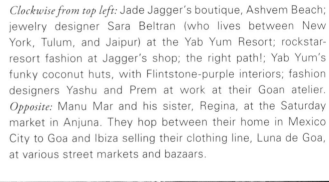

Clockwise from top left: Jade Jagger's boutique, Ashvem Beach; jewelry designer Sara Beltran (who lives between New York, Tulum, and Jaipur) at the Yab Yum Resort; rockstar-resort fashion at Jagger's shop; the right path!; Yab Yum's funky coconut huts, with Flintstone-purple interiors; fashion designers Yashu and Prem at work at their Goan atelier. *Opposite:* Manu Mar and his sister, Regina, at the Saturday market in Anjuna. They hop between their home in Mexico City to Goa and Ibiza selling their clothing line, Luna de Goa, at various street markets and bazaars.

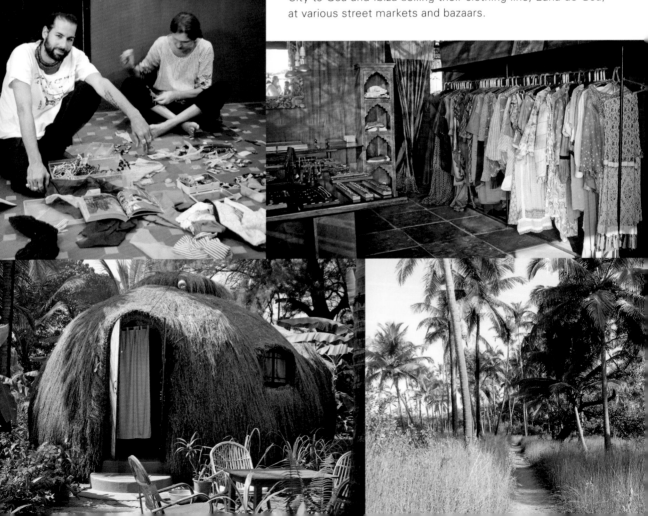

BYRON BAY

"Dare to be naive."
R. BUCKMINSTER FULLER

Dirty dishes piling up in the kitchen sink have been the ruin of many a makeshift utopia. Consider Millbrook, a rambling mansion in upstate New York where drug guru Timothy Leary camped out with his numerous friends and followers. "Nobody was ever going to do the dishes," Charles Slack, a visitor, recalled in *Timothy Leary: A Biography.* "Certainly Leary was not going to do the dishes. Ever. Who was going to do the dishes? Throughout the '60s, that became sort of a thing because different people kept echoing that phrase."

Byron Bay, a surf town located on Australia's northeast coast, is the type of idyllic communal place where the dishes do manage to get done. It's filled with neo-hippies, buskers (street musicians), and surfers. But don't let the dreadlocks and tattered board shorts fool you. Unlike the deadbeat crowd at Leary's Millbrook, many of Byron's inhabitants are organized environmentalists and alpha activists. Plastic water bottles are practically illegal and organic-compost-fueled veggie gardens—some even potted on the dashboards of vans—are the norm.

Captain James Cook came ashore in the 1770s and named the town after the explorer John Byron, the grandfather of the louche English poet Lord Byron. Fitting ancestry, as the poet was a gypset icon who flitted among off-season European palazzos stocked with lovers, fellow writers, and pet monkeys. Surfers discovered Byron Bay in the 1960s, drawn by South Pacific breaks such as The Pass, Wategos, and Cosy Corner. But unlike most semi-settled paradises, where time takes its toll in the form of gated

Spell and The Gypsy Collective, a Byron Bay fashion label.

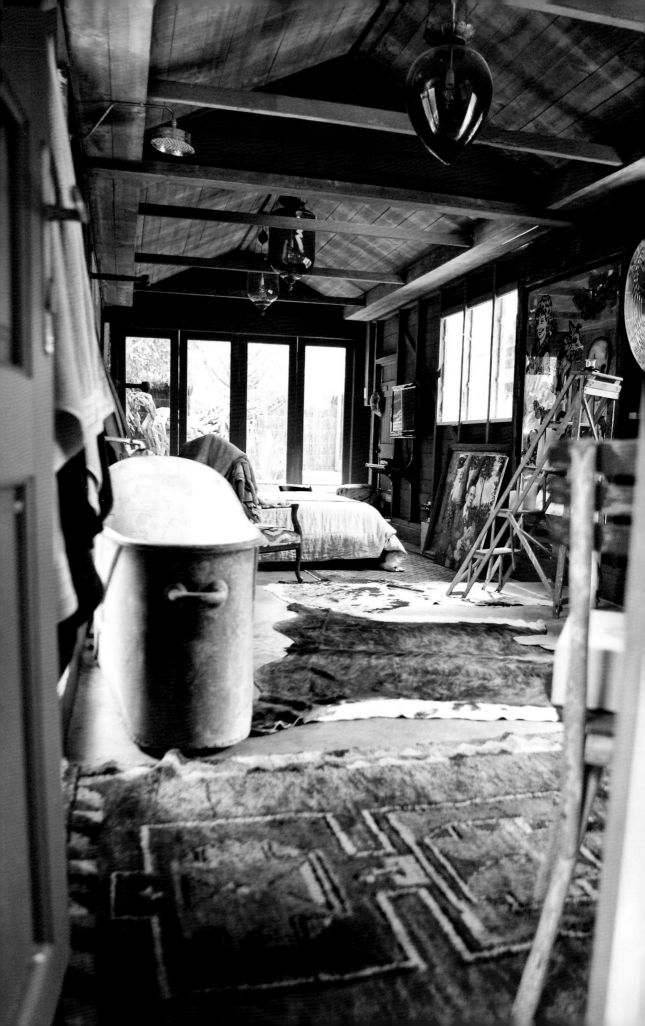

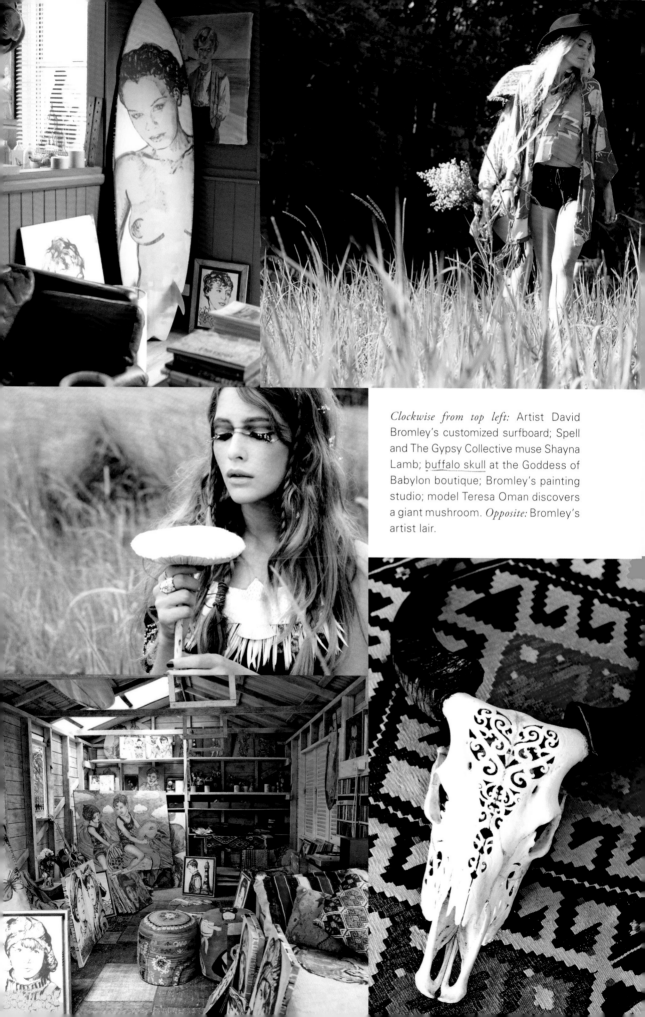

Clockwise from top left: Artist David Bromley's customized surfboard; Spell and The Gypsy Collective muse Shayna Lamb; buffalo skull at the Goddess of Babylon boutique; Bromley's painting studio; model Teresa Oman discovers a giant mushroom. *Opposite:* Bromley's artist lair.

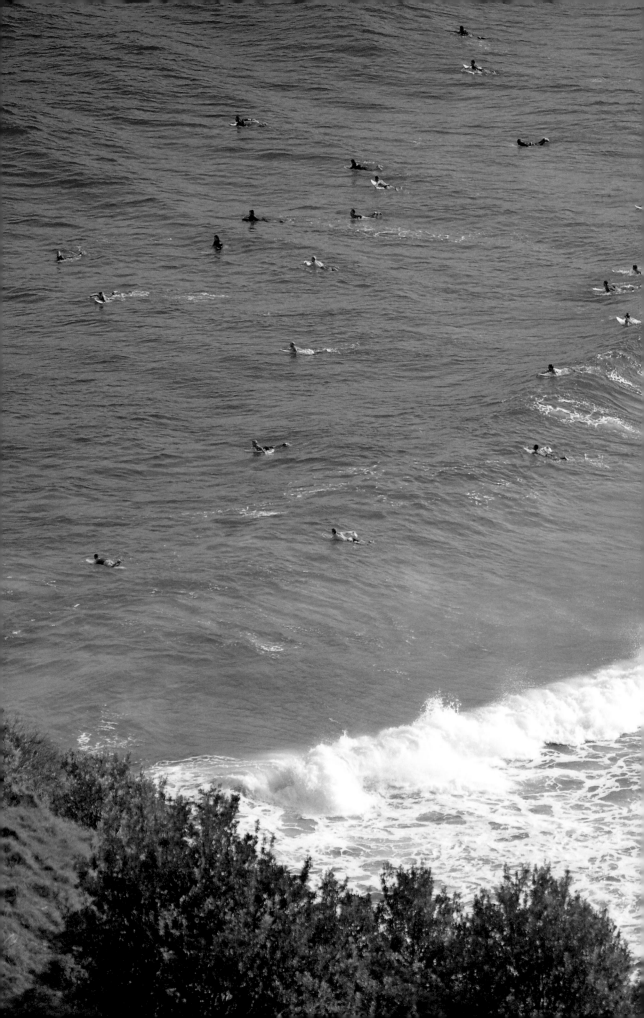

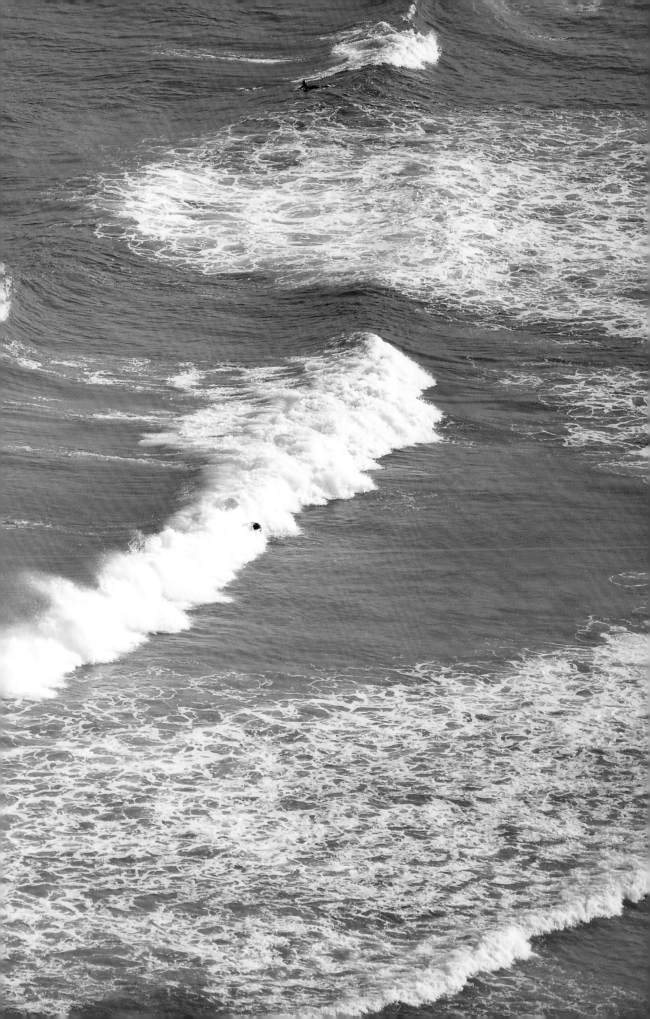

communities and shopping malls, Byron Bay is in many ways better off now than it was during the mid-twentieth century. Back then, the brutal whaling industry was still going strong, and much of the countryside had been deforested for cattle ranching. But in the 1980s the community mobilized against commercial development and non-ecological businesses, and now Byron is one of the more progressive and preserved corners of Australia.

Waterfalls cascade into subtropical rain forests and rainbows stretch across ancient valleys. It's as surreal as a fairy tale. And in fact, fairy culture runs deep in Byron Bay—perhaps because the aboriginal songline "Fairy Emu Dreaming Lore," which relates ancient indigenous myths, crosses right through the peaks of Mount Warning, an imposing chunk of an old volcano. Modern-day fairies abound at gatherings, street markets, and festivals. "Some have wings, others recite poetry, and a special few dance like there is no tomorrow," a local website attests.

Byron Bay's transcendentalist allure is a major draw for professional surfers and good-vibe musicians like Angus Stone and Jack Johnson, who keeps a house in nearby Lennox Head. Ben Harper filmed his music video for "Diamonds on the Inside" here with shots of vintage station wagons and hot surfer girls in rash guards—not thongs.

"I had been trying to get to Byron for ten years," says Sybil Steele, a photographer from Southern California who recently moved to Byron Bay from Bali with her husband, Taylor Steele, a surf filmmaker, along with their two daughters. "There aren't any Targets, McDonald's, or freeways," she says. "People just want to surf and enjoy life. Ladies sell fairy [dolls] with felt wings at the market."

Dave Rastovich, a soul surfer and activist, is one of the area's most gypset residents. Soul surfers don't compete for money, but Rasta (as he is known) is sponsored by several brands that pay him to travel around the world and have fun. I can't think of a better job. He's constantly on surf safari to Tahiti, Mexico, and Alaska to work on surf films and his many environmental causes, including Sea Shepherd and Transparent Sea Voyage. During downtime he can be found at his home—a single room cabin that runs on solar power and rain water tanks—up in the Byron hills, where he gardens and meditates "with lots of clean air and colors to breathe in every day," says Rasta. If an epic swell rolls in, schedules must be cleared and work called off. Most people in Byron Bay are freelancers— fashion design, music, and surfboard shaping are popular professions. Hardly anyone works in an office building. In fact, there aren't any office buildings, at least not in the high-rise sense.

Locals also dress like they're on permanent vacation or perhaps en route to a music festival. The town plays host to several big events, including the East Coast Blues & Roots Music Festival and Splendour in the Grass. Why not wear a bikini under that feathered coat today? Thigh-high moccasins and turquoise headdresses won't raise brows in the morning latte line.

Previous pages: One of Byron Bay's idyllic surf breaks—but you'll have to find it yourself. *Opposite:* Surfer and gypset child Jaiden Steele. *Following pages:* Mythical Mount Warning.

Homegrown fashion labels Spell and the Gypsy Collective (Sienna Miller and Taylor Swift are fans), Buffalo Girl, and Goddess of Babylon stitch up creations imbued with Byron's unique set of references: Southwest Native Americans, sexy beach nymphs, and a touch of tribal Aborigine. "It's about dressing in that free-spirit, costume way all the time," says Elizabeth Briedis, who runs Spell and the Gypsy Collective with her sister, Isabella.

You might see DIY versions of the look on the backs of traveling musicians who clog the sidewalks of downtown Byron Bay. Melody Moon, a young singer-songwriter from Victoria, lives in her van, a 1974 Volkswagen Kombi camper she named Nina, in homage to Nina Simone. Tomatoes grow in pots by the windows, and the cupboards are decorated with fairy paintings. Melody resembles a cute forest pixie, with her pierced nose, short black bangs, and ethereal, childlike voice.

For the last five years Melody has been cruising around Australia's Gold Coast and beyond performing in small towns like Bellingen, Bermagui, and Bega, as well as at Brisbane's MindBodySpirit Festival. The van is packed with her instruments—an acoustic guitar, keyboard, and glockenspiel—and a collection of fairy dresses, the stage clothes for her alter ego, Fairy Melody, a children's entertainer.

When in Byron Bay, Melody often plays gigs at the Treehouse, a folksy music venue near the beach, where she likes to take preshow swims. At night she drives Nina into the forest and camps out amongst the glowworms and ferns. Occasionally she'll jam with friends like Rachel by the Stream, a singer-songwriter who worked as a crystal polisher and ghost hunter in Cornwall, England, before joining Australia's traveling musician scene (see chapter 2). "Last time I was up in Byron, I made friends with the local circus crew," says Melody. "I learned the flying trapeze and dated a circus instructor."

Of course the best thing about living solo in a van is you don't have to wash anyone else's dishes. Not that Melody would mind.

Following pages: Byron musician M. Jack Bee breaks between gigs.

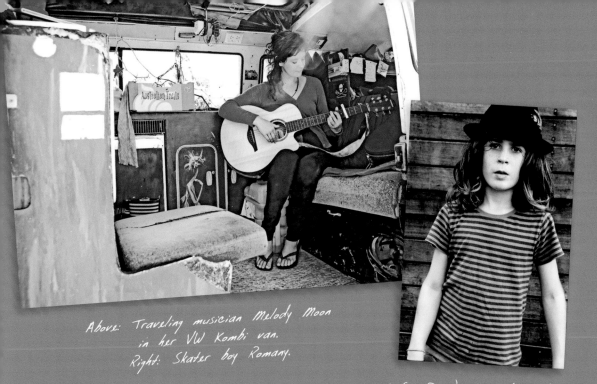

Above: Traveling musician Melody Moon
in her VW Kombi van.
Right: Skater boy Romany.

Left: Byron's guru hairstylist,
Bries and her Rhythm Stick
surfboard. Below: The very
stylish sister and brother music
duo Julia and Angus Stone.

From left: Soul surfer Dave Rastovich in the Byron hills with wife, Lauren; surf
filmmaker Taylor Steele at Mavis Kitchen in the foothills of Mount Warning.

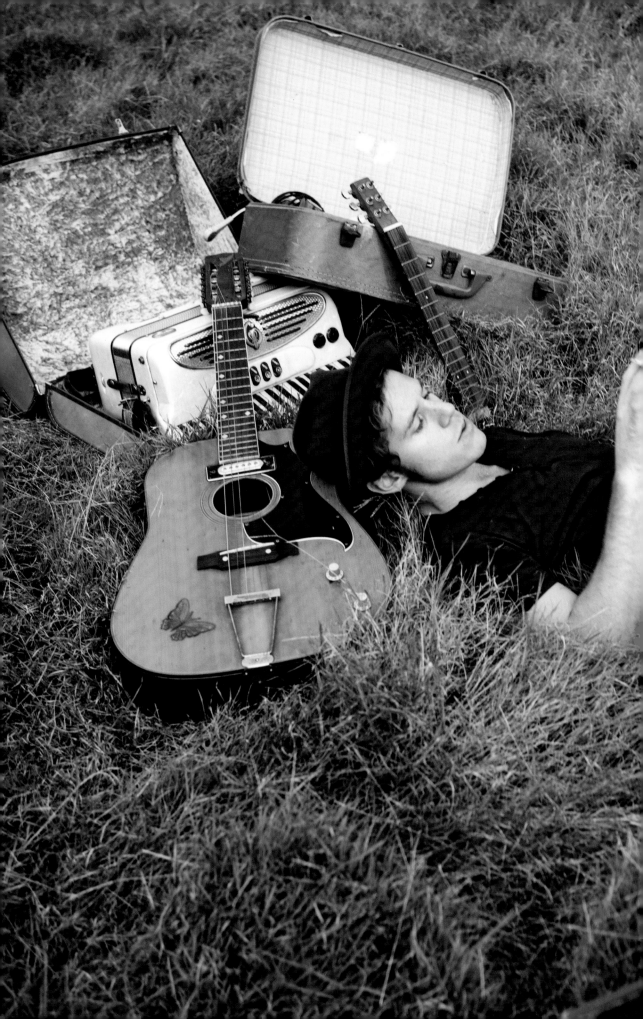

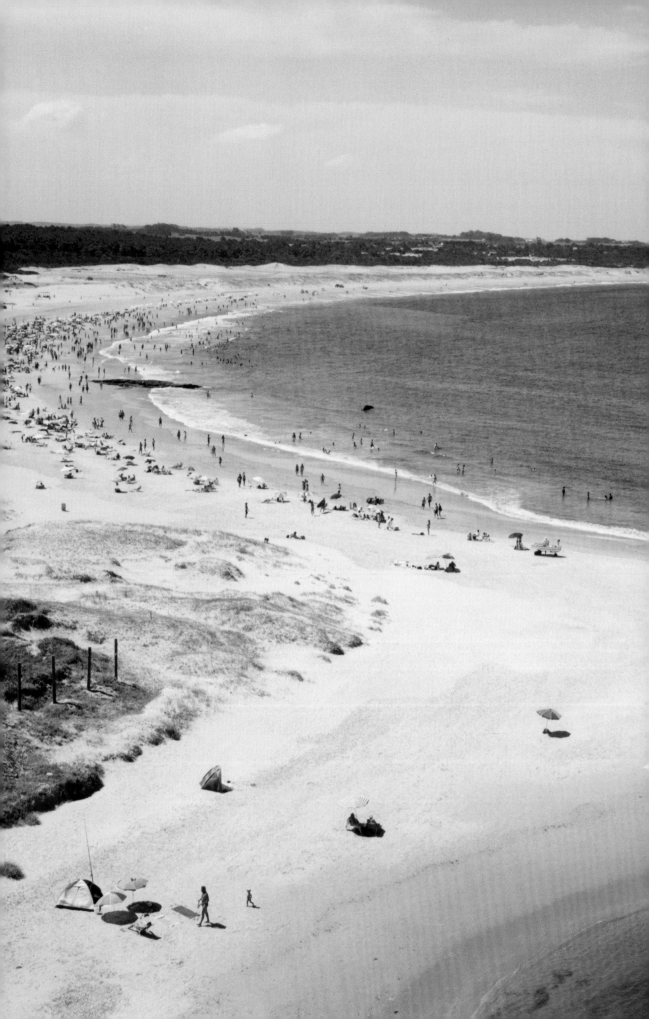

JOSÉ IGNACIO & CABO POLONIO

*"Who is the gaucho amigo/ Why is he standing/
In your spangled leather poncho/ And your elevator shoes."*
STEELY DAN, "Gaucho," 1980

I n the 1980s the jet set flocked to Punta del Este, a beach resort in Uruguay about a forty-minute drive south of José Ignacio. They came for its amped-up social scene and lax banking laws, and ended up creating a sort of South American Monaco. Beaches were lined with high-rises and casinos: interchangeable concrete monoliths united in their devotion to marble lobbies, air-conditioning, tinted windows, and fortress-like security. It was the epitome of conspicuous consumption, and tycoons like Aristotle Onassis came to show off their big yachts and bigger egos. But somewhere in the mid-1990s tastes began to change, and in Punta the intrepid hoteliers, visionary restaurateurs, and a few idealistic architects bailed to venture up the coast. They set up shop in sleepy José Ignacio, an area abundant with nothing but the elements: sand, sun, wind, and the wild ocean. Sophistication was redefined as organic and soulful, and a gypset aesthetic was born.

The trendsetter was the Argentine chef Francis Mallmann: He opened his restaurant Los Negros by José Ignacio's lighthouse and served up his Andean brand of nouvelle cuisine in an earthy dining room overlooking the crashing waves. The boutique hotel La Posada del Faro reworked the traditional components of gaucho architecture—ranch-size fireplaces and colonial antiques—into something similarly sublime.

Bird's eye view of Brava Beach in José Ignacio.

But it's La Huella, a relaxed restaurant on Brava beach, that sets the watermark for gypset chic. Housed in a basic *parador* (Spanish for "inn"), the eatery loans patrons alpaca shawls to throw over their shoulders when the wind picks up and the night temperature drops, as it inevitably does. Its basic decor of raw, local woods and hearth fires negates pretension. I was in José Ignacio over New Year's, which is the peak of the party season in Uruguay. I spent almost every lunch, dinner, and after-dinner drink parked strategically at La Huella's bamboo bar—José Ignacio's social nexus. I met everyone in town: fashion designers from Buenos Aires, a Venezuelan filmmaker, Italian financiers, polo players, and others I only hazily recall. With no plans for New Year's Eve, I simply trolled around town with my new friends, crashing house parties wherever we heard good music; the doors were always open. A fantastic night!

Other nights were much the same. Socialites, movie stars, and the determined peeled about José Ignacio like modern-day gauchos on the hunt. Sometimes it felt like everyone had disappeared, and then I would discover a midnight traffic jam at the end of a bumpy dirt road, as well-dressed partiers unloaded to find a secret restaurant hidden among the trees or a gathering at a eucalyptus-lined estancia.

During the day, one of my favorite things to do was pedal a bicycle around the sandy streets and check out the unconventional homes. You can find everything from log cabins with minimalist lines to adobe cottages with grass roofs so exaggerated that they look like sombreros. Nantucket it's not. A group of well-traveled urbanites have created a collective aesthetic informed by the gaucho. These South American cowboys reigned in the eighteenth and nineteenth centuries and were semi-nomads, galloping around the flat countryside in ponchos and *bombachas de campo* (loose-fitting trousers). They were folk heroes frequently invoked by writers and balladeers as righteous fighters against the corrupt establishment. They cooked on an open flame (*asado*) and slept under the stars.

Unlike what happened to Punta del Este in the 1980s, the gentrification of José Ignacio looks so much like the real thing that, except for the fresh paint and open floor plans, you can hardly tell them apart. Jet-setters abound in José Ignacio, but they appear gypset. And even if they resist, the raw, earthy gaucho environment slowly transforms them.

In many ways José Ignacio, which took about ten short years to transform from a nondescript fishing village into one of the chicest slabs of land in the world, is the template for the gypset aesthetic. Yet the truth is that there are not many gypsetters left at this point; the hard-core pioneers who colonized José Ignacio have already moved on.

Francis Mallmann was the first to go. A few years ago he shut down Los Negros and headed inland to Garzón, a nineteenth-century wheat-farming town about a half hour drive into the expansive

Following pages: Laura Rios Castro and Emilia Cercnian from Montevideo vacation in a Cabo Polonio bungalow. *Pages 124–125:* A stylish squatter compound in Cabo Polonio.

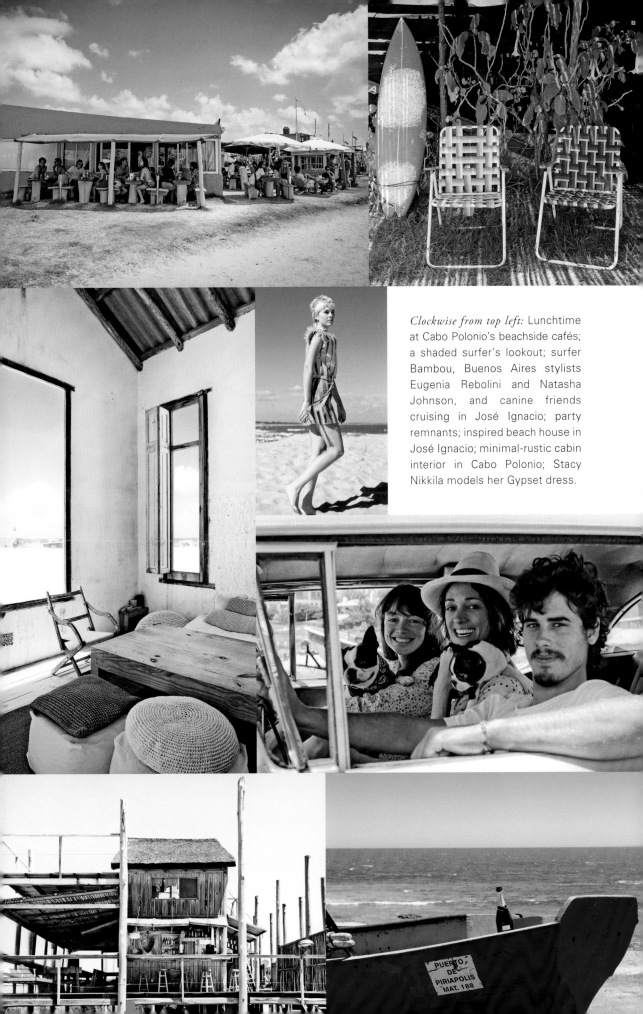

Clockwise from top left: Lunchtime at Cabo Polonio's beachside cafés; a shaded surfer's lookout; surfer Bambou, Buenos Aires stylists Eugenia Rebolini and Natasha Johnson, and canine friends cruising in José Ignacio; party remnants; inspired beach house in José Ignacio; minimal-rustic cabin interior in Cabo Polonio; Stacy Nikkila models her Gypset dress.

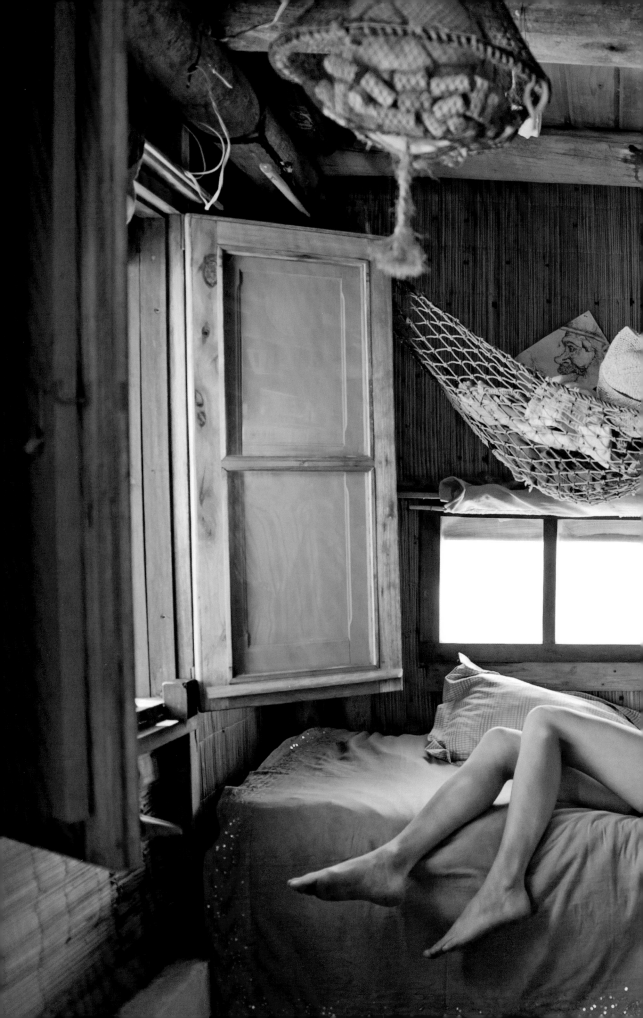

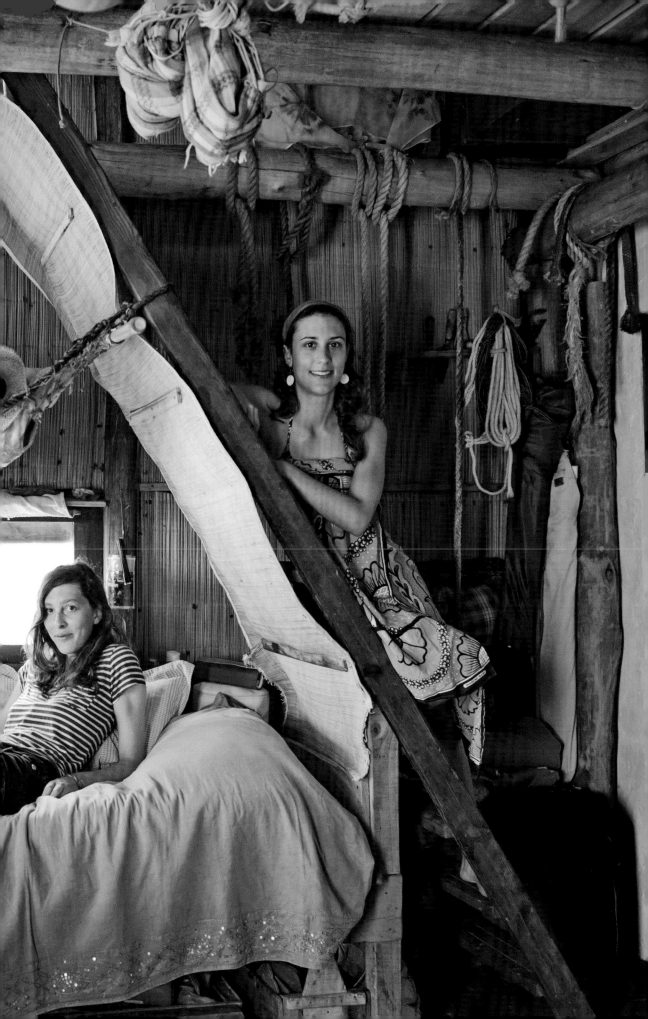

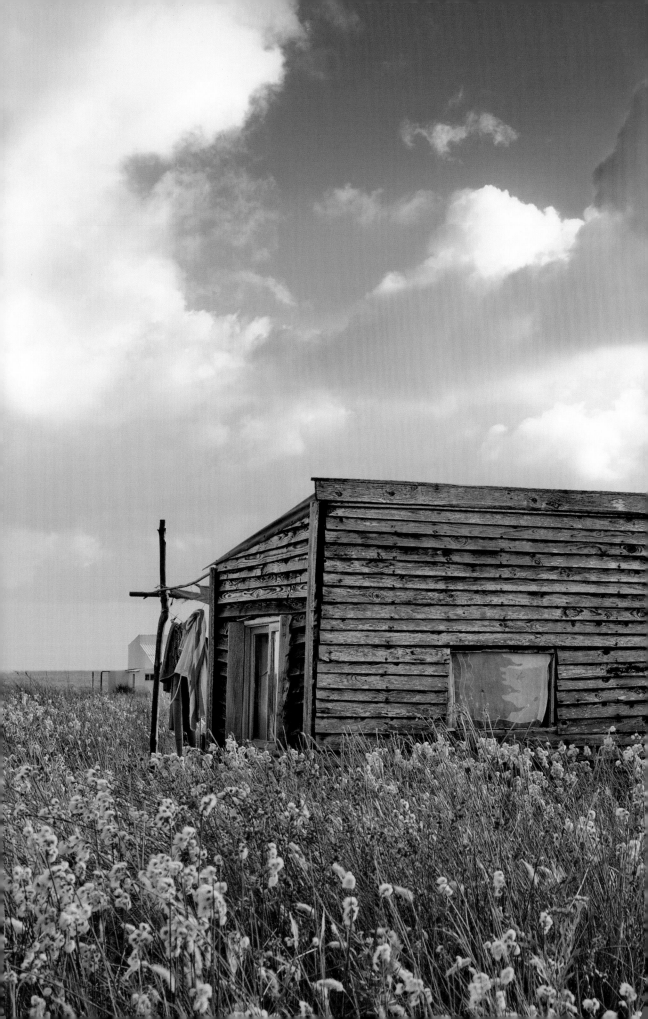

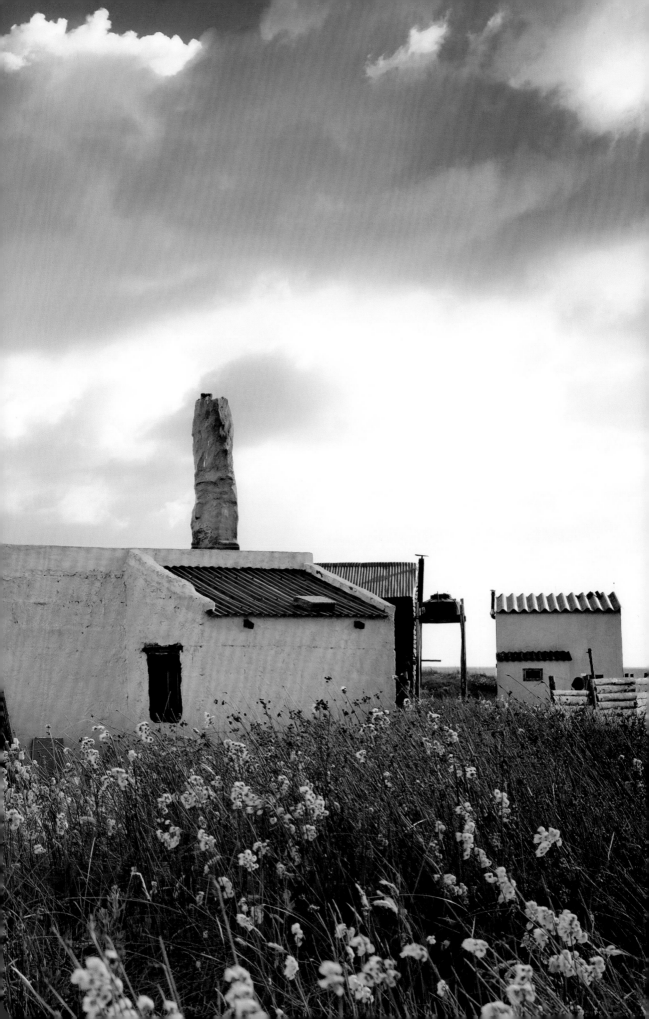

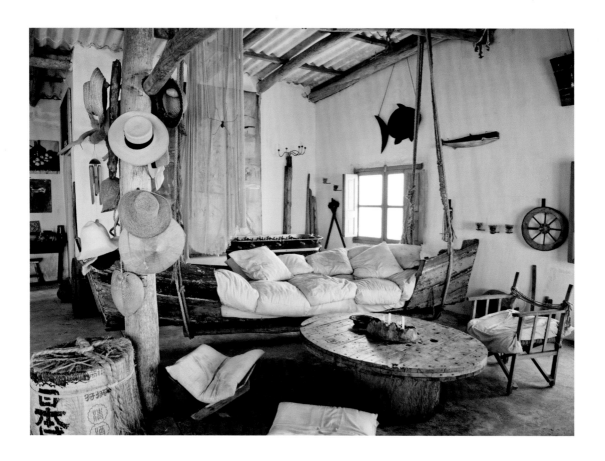

countryside. Now he owns a large percentage of downtown Garzón's weathered brick warehouses and cement buildings. Mallmann's new place is an elegant restaurant and pitch-perfect boutique hotel called El Garzón. Foodies make the pilgrimage from all over, but what draws them is more than the cuisine. Mallmann has created a mini-utopia—much like Donald Judd did in Marfa, Texas—complete with a good-life philosophy and a distinctive visual language. Garzón is the pastoral-chic mecca, with an organic farm with stray cows and horses meandering through the lush vegetable gardens and absolutely no modern distractions. And he has his disciples. All over town young, artsy pioneer types are setting up labor-of-love businesses behind spruced up storefronts. Lucía Soria, who worked in Mallmann's kitchen for nine years, now has Lucifer, a rambling café in the courtyard behind her house. The tables are alfresco, there is poetry scrawled on the walls, and the Rolling Stones play on the stereo. When I was there, I ate a lazy afternoon lunch of blue cheese polenta and carne asada—one of the best meals I'd had in years.

But the hardest core can be found even farther up the coast, in Cabo Polonio. The seaside settlement is one of the coolest and most bizarre places I've ever visited—gypset to the bone. The land belongs to the government, but the dunes have been settled by squatters over the years. Small ad hoc shacks made of everything from old bottles to driftwood dot the area, each a reflection of its builder's fetish. Some are hippie-dippie, dome-like, and painted purple. Others are more homestead-

Above: Architect Andres Ferreyra's beach shack in Cabo Polonio. *Opposite:* Sleeping quarters in an estancia in the hills behind José Ignacio. *Following pages:* A horse roams near the dunes in Cabo Polonio.

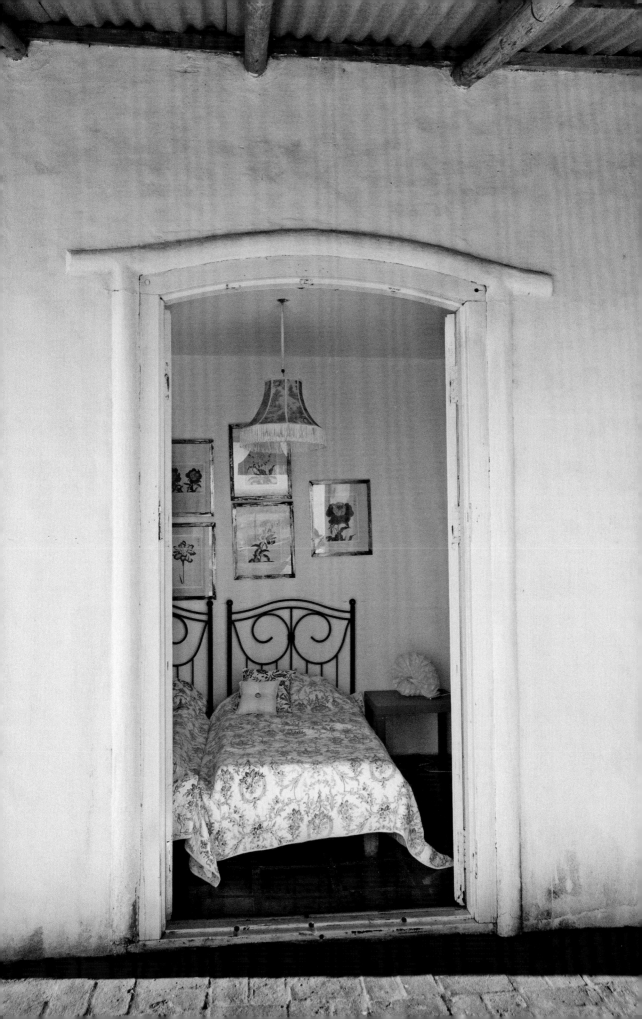

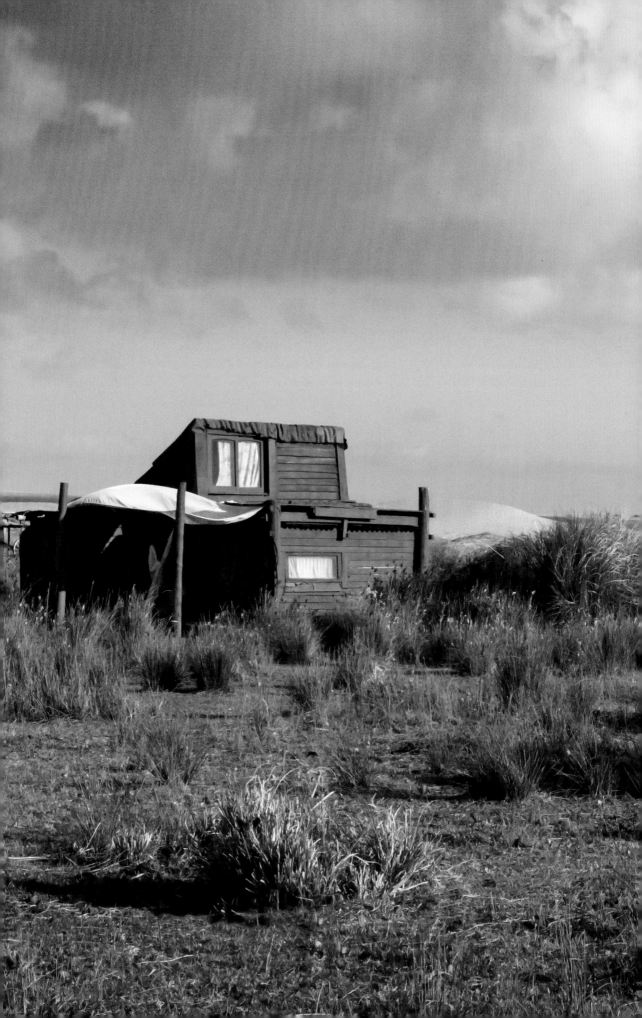

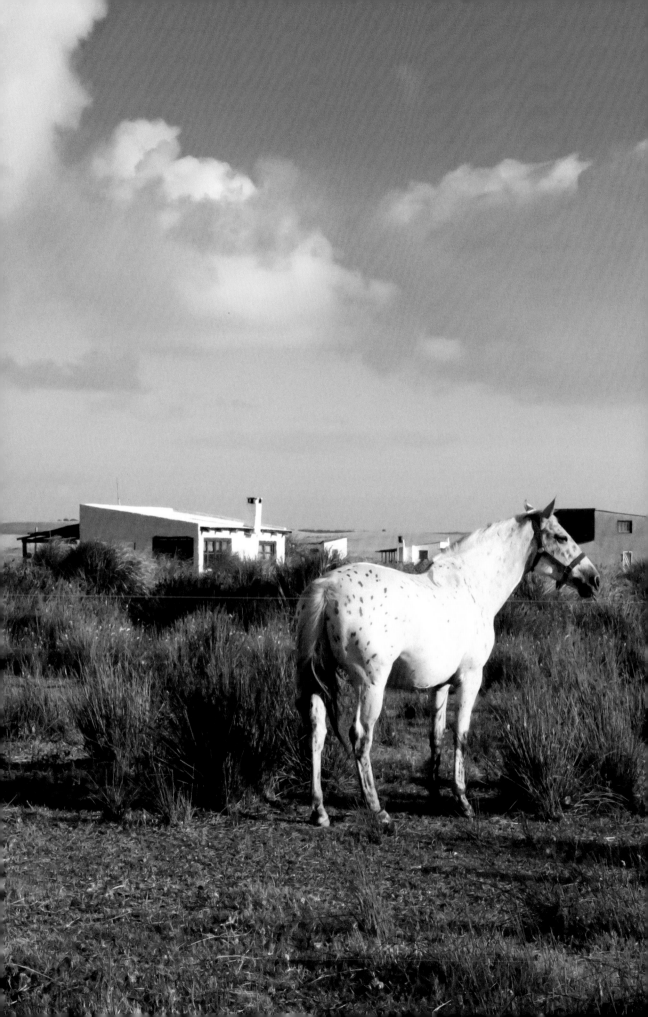

"FRENCH COOKING, ELEGANCE, LUXURY—ALL THE BEST THAT I COULD IMAGINE. NOW IT'S JUST SORT OF GONE BACKWARDS TO RETURN TO MORE SIMPLE THINGS. WHEN YOU GO SIMPLE AFTER GOING THROUGH ALL THAT SORT OF SOPHISTICATED PATH, IT'S WONDERFUL."
—FRANCIS MALLMANN

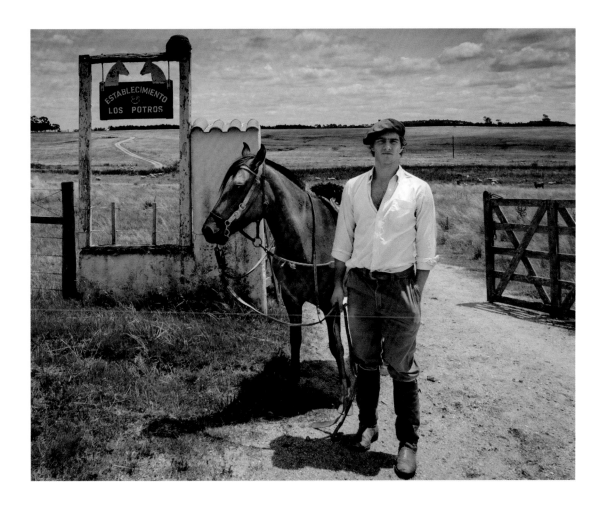

Above: Gaucho culture on display in the Maldonado countryside.
Opposite: The tack room at a 1940s estancia.

Clockwise from top left: Finding direction in José Ignacio; abandoned railroad station in Garzón; après-beach nibbling at Belcampo Mercado; Francis Mallmann's restaurant; Montevideo art school grad Carolyn Prevett at her Alium Design Studio in Garzón; campo beach architecture in José Igancio; interior of a family estancia.

inspired: tiny one-room cabins, but built with low lines and a modernist silhouette. One shack is a perfect reproduction of a Tuscan villa—only it's not much bigger than a king-size bed.

"The houses here are handmade, not designed," explains Andrés Ferreyra, an architect who has built several cabanas in Cabo Polonio. He arrived in the 1980s by horse and buggy, the only way to access the village at that time. Cars are still not allowed, but getting there now is just a matter of hopping aboard a four-wheel-drive shuttle truck. There still is no electricity, and fresh water must be pumped in manually from little wells. In the mornings, residents bathe in the ocean.

I meet Andrés at his beach shack and he invites me inside for a tour. His wife is sitting on the porch in the lotus position, silently meditating, and we do our best not to disturb her. Andrés is part of the first wave here; his balding pate with its fringe of graying hair tells me that immediately. "I was running away from Punta del Este," he explains. "I like places that are more solitary." His house is decorated entirely from found objects. The kitchen shelves are large, flat stones hanging from the ceiling on splintery twine. A big piece of driftwood holds up the dining table, and an old fishing-boat hull doubles as the couch. "It took years to build this house," he says. "One day you carry in a door, the next a plank of wood. Then you ask a guy to build a wall and he disappears for a month."

It's easy to find a house to rent for a night, a couple of weeks, or even longer. I checked into a little shack near the center of the village, where vendors were selling handmade jewelry and crocheted vests. At night a few generators whirl, but mostly everything is lit by candles and small fires. Makeshift restaurants and bars buzz with patrons who come for fresh-from-the-ocean specialties like *milanesa de pescado* and calamari. At sundown the liquor store is mobbed with locals. There are no streetlights; people make due with flashlights or the light of the moon. After dark, parties begin to form on street corners and porches. Instruments break out, and people dance and set off fireworks till dawn. Despite the considerable racket, no one complains. Even if they did, I'm not sure who would be there to listen.

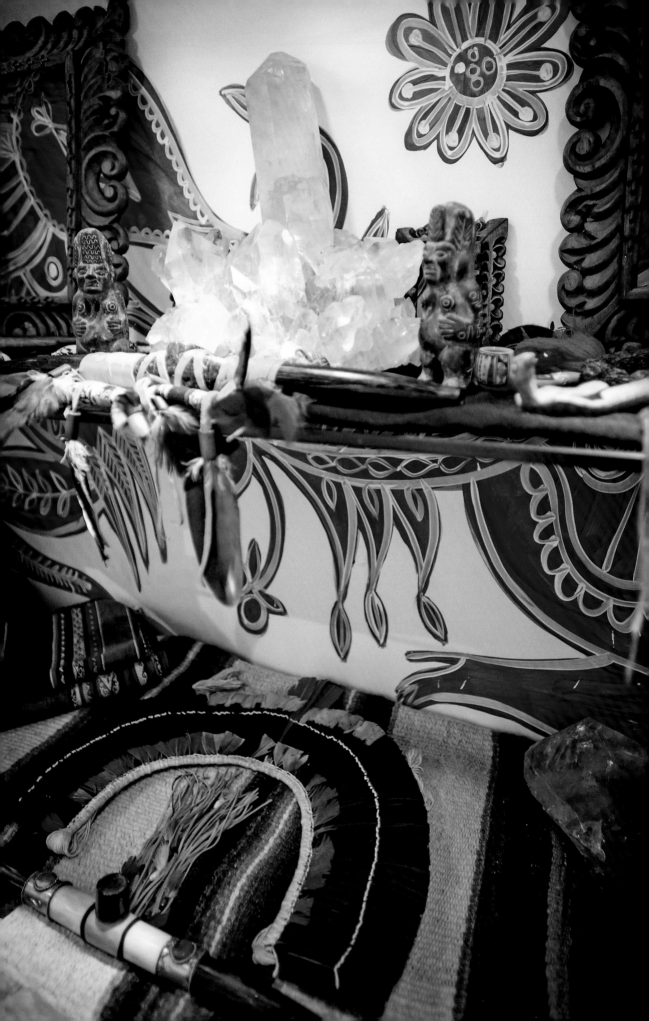

ALTO PARAÍSO

"Please wear white, bring a sleeping bag, and don't eat for several hours beforehand. Is it your first time? Yes? Well, that's OK. You will be with experienced drinkers"

ERAN (an Israeli guy I had just met at the *pousada*)

D ay one in Alto Paraíso, Brazil: Daniele, my photographer friend, and I haven't even finished our breakfast papaya, and we've already been invited to a three-day wedding that kicks off tonight with an ayahuasca ritual for fifty. Ayahuasca, which translates as "spirit vine," is an Amazonian tribal medicine that causes hallucinations and is said to transport you spiritually and beyond—way beyond. I'm nervous, but you can't go to Alto Paraíso and not participate. It would be like going to Paris and skipping the Louvre, or visiting the Italian capital and blowing off the Colosseum. And you know what they say: "When in Rome…"

So we dig out some white Hanes tank tops and sweats from our luggage and, looking more like we're heading to yoga class than to a wedding, make our way down a highway pocked with so many potholes it feels like we're in a Boston Whaler. At the end of a muddy dirt road that leads to the top of a hill is a huge, modern house belonging to the wedding's host, Christof, a German trance DJ who spent years living in North Goa (see chapter 6). Thick, verdant nature goes as far as the eye can see, and the rolling night sky is heavy with rain clouds. The crowd, wearing white robes and demure peasant skirts, has already assembled on the floor. Musicians with flutes and didgeridoos, a few shamans, and the bride and groom sit in front. The groom's mother, an Israeli lady who lives in Fairfield, Connecticut, is seated pasha-like in the room's only chair. "I thought there was going to be a Shabbat service!" she keeps muttering. It reminds me of photos I've seen of cultish hippie communes from the

Opposite: Crystals and tribal artifacts on display at Galleria Agami. *Following pages:* One of the many dramatic waterfalls in the Chapada dos Veadeiros mountain range. *Pages 138–139:* Fashion model and eco-pioneer Sean Souza; Sean's off-the-grid tree house.

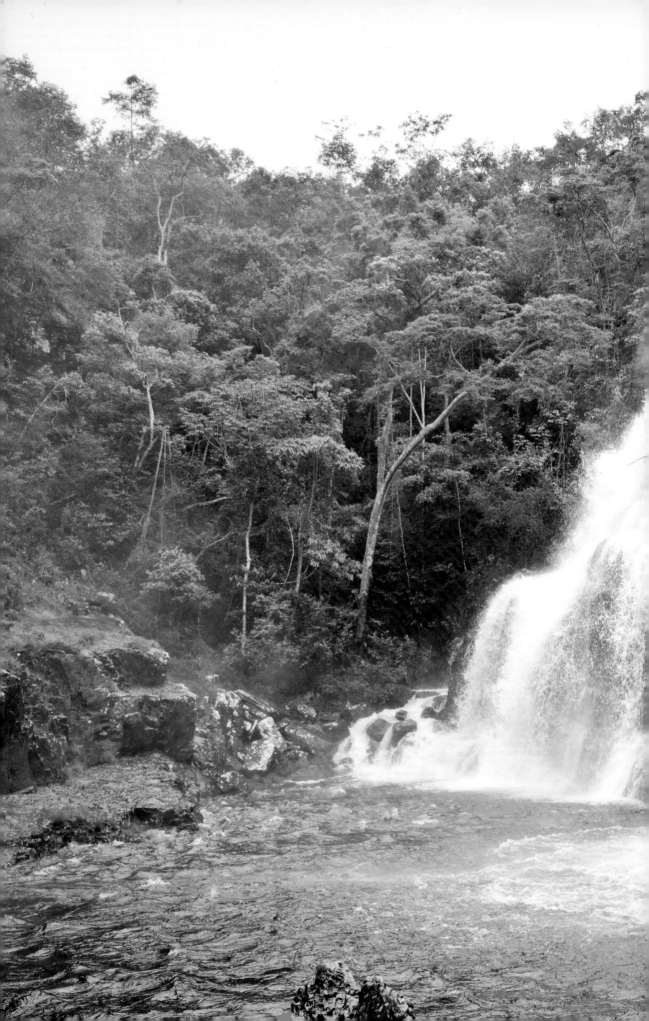

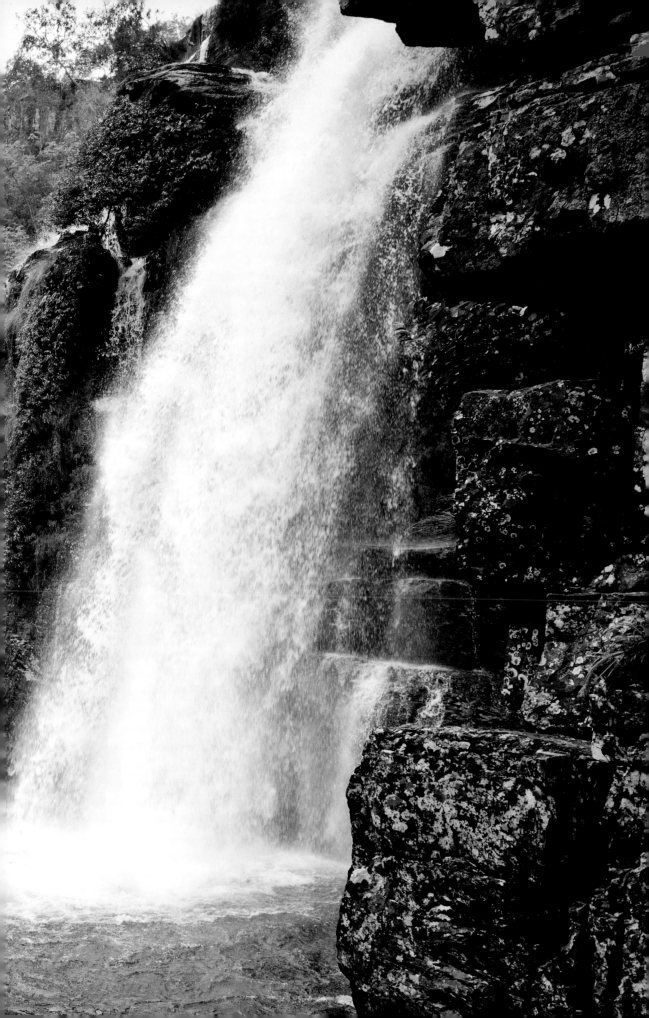

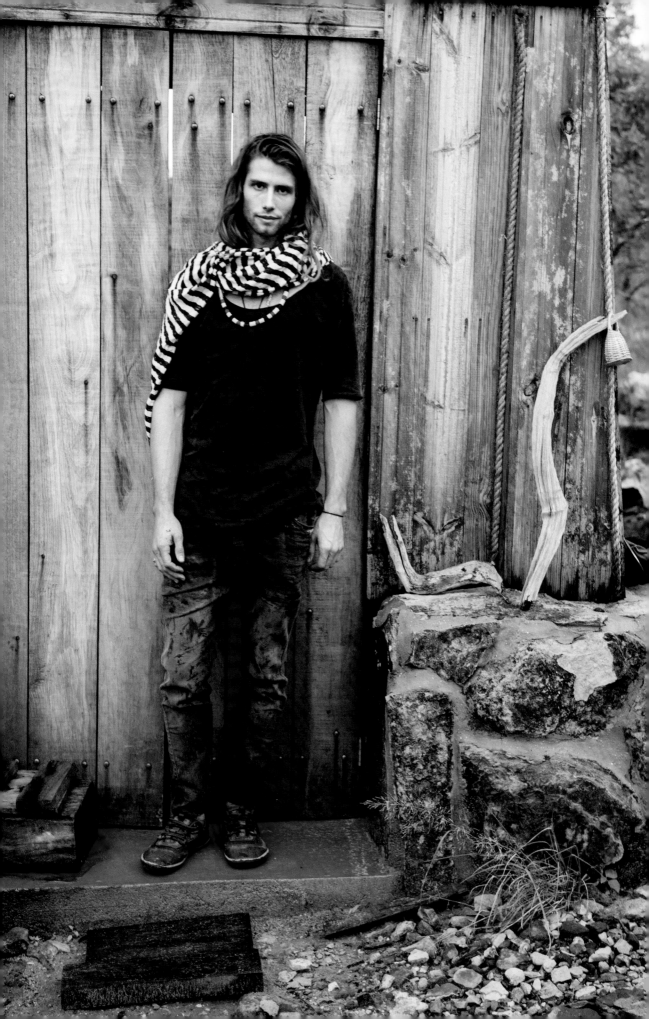

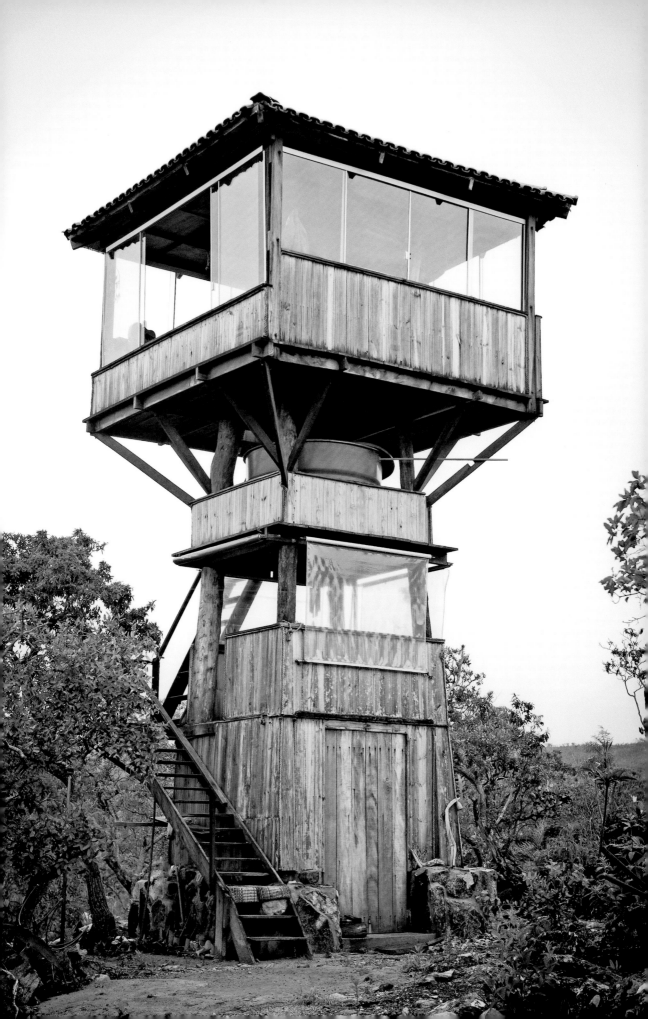

1970s—except this time I'm in it. One of the shaman's assistants, a beautiful woman with long brown ringlets, hands each of us an espresso-size shot of the pulpy, alkaline-tasting brew, and off into the spirit world we go. I won't give away the ending, except to say that Alto Paraíso makes a lot more sense once you've taken ayahuasca. Note to self: Don't smuggle your bedspread to an ayahuasca ceremony because the innkeeper will likely be there, as will every other business owner in town.

Tucked in the fertile Chapada dos Veadeiros mountains, about a three-hour drive from the capital, Brasília, Alto Paraíso has emerged as the destination for a new wave of spiritual globe-trotters. In Goa, Ibiza, or St. Barths—places anointed by proto-gypset hippies in the 1960s and '70s—there's the feeling that you may have arrived too late, that the good times ended decades ago. But in Alto, as the locals lovingly call it, the exact opposite is true. You feel like you've arrived on the early side of things.

Rules have yet to be made, and parties rage till the last person drops. Trance DJs relocated from Goa are in the process of forging a new "electro-shamanic" sound—a mash-up of bossa nova and ceremonial chants. Land is relatively cheap: UFO believers flocked here in the 1980s, but they've since moved on, leaving their domes behind. Ayahuascans rule now. For every shaman and Reiki healer there's a handful of European socialites, models, or fire dancers fresh from the Cirque du Soleil.

Above: Novo New Age graffiti in downtown Alto Paraíso. *Opposite:* Performance artist/dancer Amber Joy Rava at YogAstral. *Following pages:* The hangout patio at Jambalaya Restaurant.

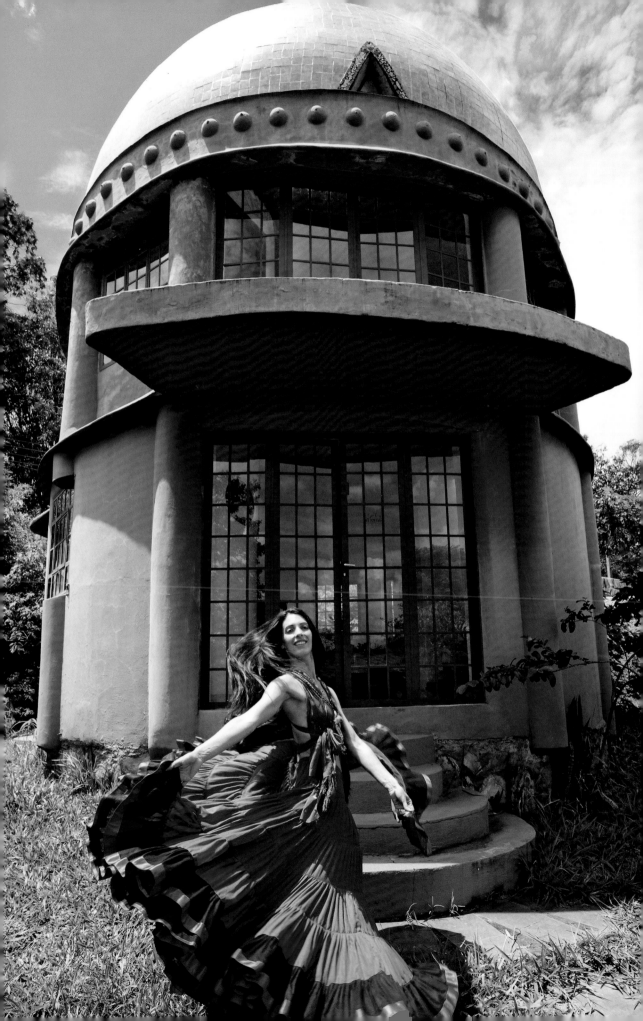

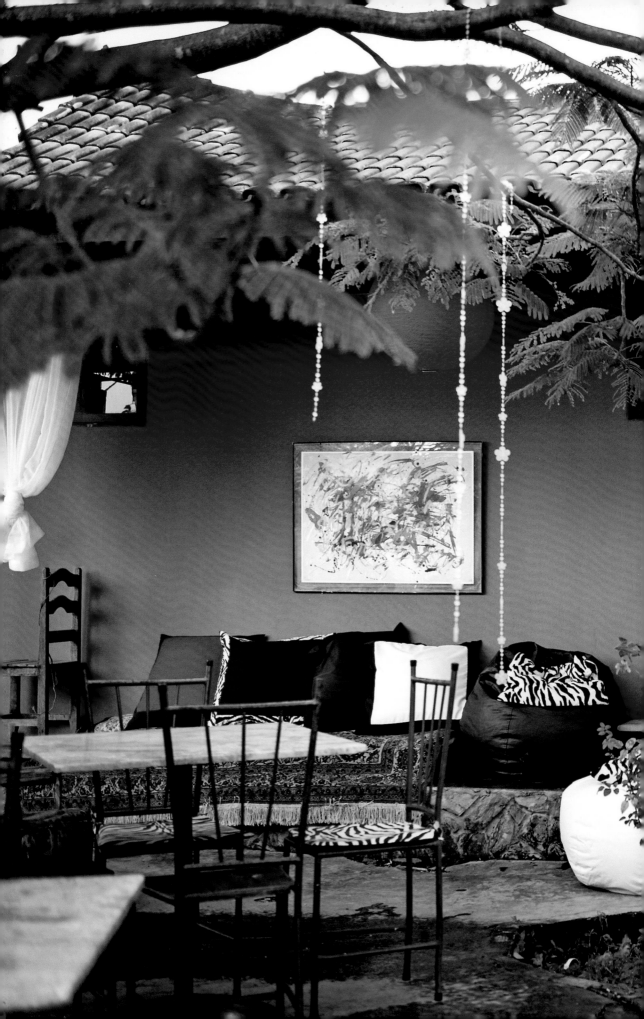

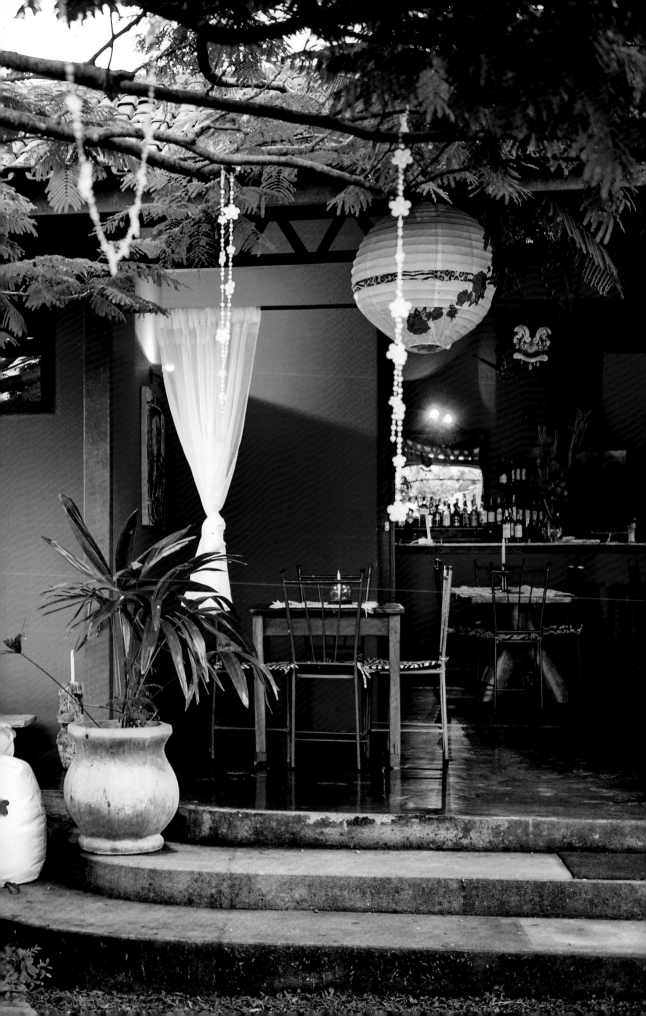

Sean Gabriel Souza, the son of Brazilian fashion magnate Carlos Souza and social fixture Charlene Shorto de Ganay, is a perfect example. A male model and the godson of fashion designer Valentino, Sean is homesteading a rocky parcel of land on the outskirts of Alto that he bought for $2,000. When he's not walking the runways of Rio, São Paulo, and Milan, he's here. "Coming from an upbringing of glamour, I was able to see firsthand how much was lacking in that life," he says. Sean lives atop a narrow wooden tower with no electricity (and lots of bugs) and dreams of building a center for ecological studies. He keeps his mobile phone charged with a small solar panel in case his agent calls with a modeling job. Come fashion week, he hops on his dirt bike and makes a beeline to the airport in Brasília.

Ayahuasca, which is geared more toward inward healing than raves, could easily be this generation's LSD or Ecstasy; it's already drawn the kids to Alto. Burned out on pollution, crime, and threats of kidnapping in the cities, they've come to create a *novo* New Age. Plus, the energy is good: The world's largest crystal bed lies underneath the town, and it's so luminous that "NASA can see it glow from outer space," as the Alto Paraísanos like to say. And nearly every other person is starting some kind of "community": ecological, zoological, permacultural, sustainable—you name it. After a late night or a full moon party the blissed-out celebrants gather and caravan to one of the dozens of dramatic *cachoeiras* (Portuguese for "waterfalls") to swim in water so clean and pure you can drink it.

"You could give me a first-class ticket to anywhere, but I'd rather stay here," says Sahar Farmanfarmaian, a descendant of Iran's Qajar dynasty. Her annual rotation used to include North Goa; Ibiza; Gstaad, Switzerland; and the Pacha Mama community in Guanacaste, Costa Rica. But increasingly, she is abandoning them all for Alto Paraíso.

Sahar discovered the town several years ago, when she came for the Transcendence music festival, organized by her friend, a young Brazilian Coca-Cola heir and Osho devotee. (Disciples of the Indian guru were part of Alto's first wave and set up a commune in the nearby Lua Valley.) On a recent evening Sahar was dressed in heirloom Persian robes and wellies (rainy-season chic in Alto), holding court at her house—a sort of mini Persian palace with an indoor reflecting pool and ayahuasca temple next to it. "Alto was like Goa when it started," Sahar explains. "Two markets and just a few people. Our generation is building Alto to address our needs and our issues, not those of our parents. And I don't want to miss a second of it."

Sahar's contribution to the town is Galleria Agami, an art gallery whose main street facade is a giant keyhole painted in an ayahuascan mash of vines and faces. It was having its grand opening in a few days, and an entourage had gathered. There was her boyfriend, Cristoforo Gaetani, a musician from an aristocratic Italian family; Julio Santo Domingo, a DJ and the grandson of a Colombian

Following page: Friends gather at Sahar Farmanfarmaian's temple/atelier.
(From left: Annie Le Pigeon Sama, Thomas Csano, Carlitto Dalceggio, Iacobella Gaetani,
Sahar Farmanfarmaian, Cristoforo Gaetani, and Fernando Velasquez.)

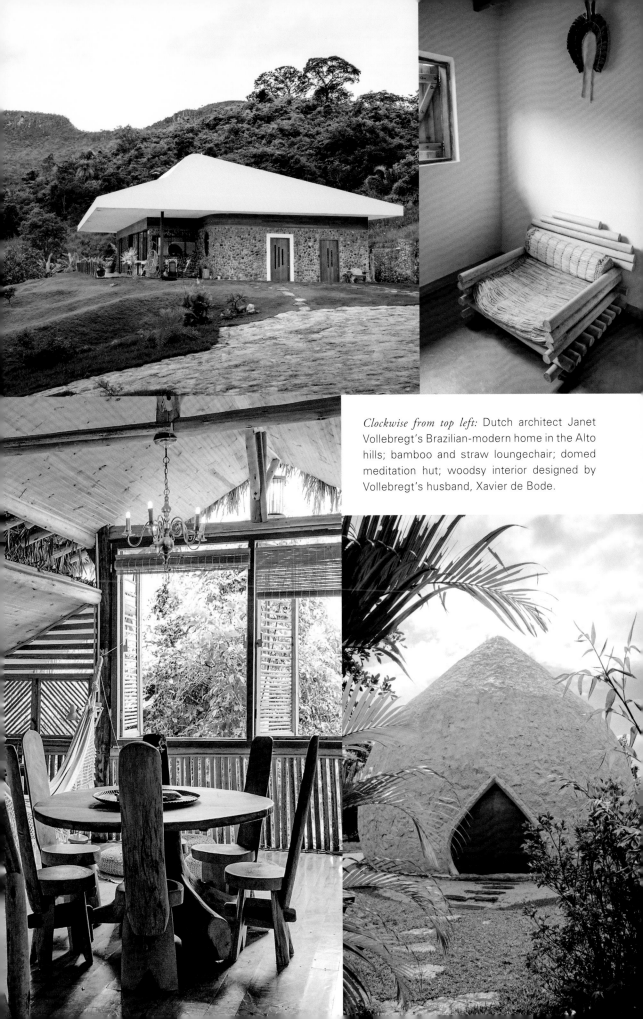

Clockwise from top left: Dutch architect Janet Vollebregt's Brazilian-modern home in the Alto hills; bamboo and straw loungechair; domed meditation hut; woodsy interior designed by Vollebregt's husband, Xavier de Bode.

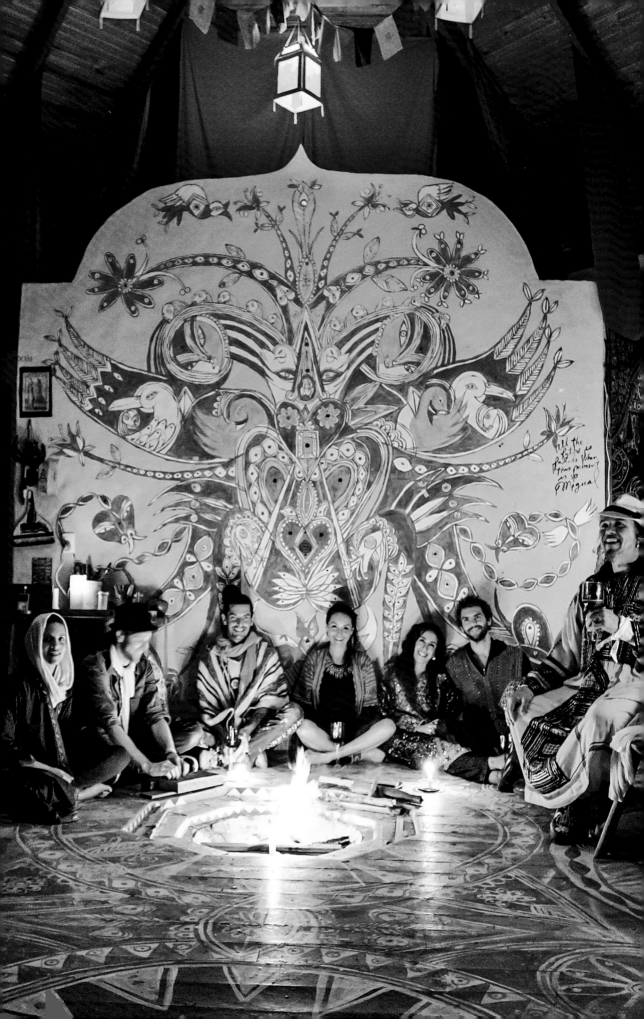

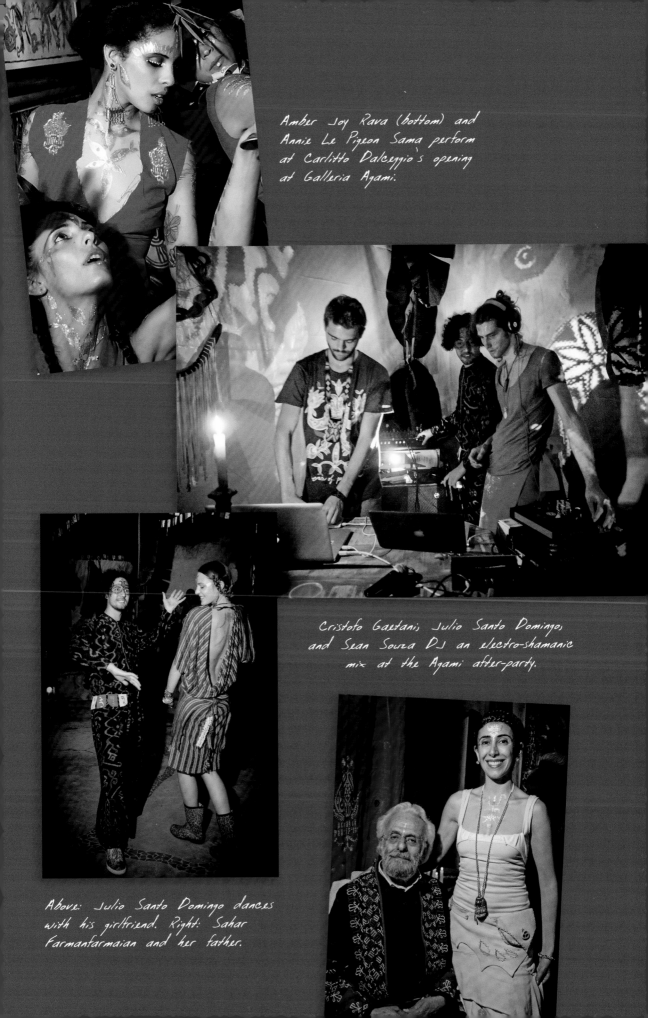

Amber Joy Rava (bottom) and
Annie Le Pigeon Sama perform
at Carlitto Dalceggio's opening
at Galleria Agami.

Cristofo Gaetani, Julio Santo Domingo,
and Sean Souza DJ an electro-shamanic
mix at the Agami after-party.

Above: Julio Santo Domingo dances
with his girlfriend. Right: Sahar
Farmanfarmaian and her father.

"DRINKING AYAHUASCA IS LIKE TURNING ON A LIGHT IN THE DARK ROOM
THAT IS YOUR BRAIN." —YATRA, LOCAL SHAMAN

billionaire; and Carlito Dalceggio, a former event designer for Cirque du Soleil and the gallery's featured artist. Lars von Bennigsen, the business partner and husband of British fashion designer Alice Temperley, and the movie producer Giancarlo Canavesio would arrive a few days later.

Yet glamour is the last word that comes to mind when describing downtown Alto. The main street—which has been renamed Kundalini Avenue—is lined with ugly, squat concrete buildings, a few painted in cliché psychedelic swirls. *Pousadas* (inns) and restaurants are similarly bare-bones, with dream catchers and crystals in the windows. A large concrete monument intended to grandly mark the entrance to town is a broken-down abstract UFO structure in the middle of the road, covered with scaffolding—a sort of wrecked-stoner Eiffel Tower that's probably been there for years.

Yet the lack of charm is hardly a deterrent to the crowds that arrive for the Condor Eagle Festival, Alto's annual monthlong ayahuasca convention. Registration was at the vegetarian restaurant EcoNois; twenty-one shamanic rituals, about BR$120 a pop, were to be held at a specially constructed temple in a papaya grove outside town. Shamans from various Indian tribes had trekked in from Colombia, Ecuador, and Brazil with vats of their "sacred medicines." One was apparently bringing frog venom. (Not all shamans are indigenous, though. I met one husband-wife duo—she's German and he's Colombian—that live part-time in an apartment in Williamsburg, Brooklyn.) Festival alumni traded names of coveted shamans like yoga instructors or DJs. An Israeli guy I recognized from the wedding, with waist-long dreadlocks and sunglasses, said he had signed up for all twenty-one rituals. Well, there's always one in the crowd.

TODOS SANTOS

"Salud y pesetas. Y tiempo para gastarlas.
(Health and money. And the time to spend them.)"
MALCOLM LOWRY, *Under the Volcano*, 1947

I n 1982 my father ended up in Todos Santos, Mexico, on a tip from some sketchy screenwriter friends in Hollywood. He had loaded his girlfriend and her two teenage daughters into an airstream trailer and hauled them from New York City all the way to the Pacific coast of the Baja California Peninsula, one thousand miles south of Tijuana. To check out his new home, I flew over from Key West, Florida, during spring break from junior high. The first thing I did was jump on top of the dining room table and scream. Dad's collection of snakes—all of which he had caught in his backyard—had escaped from their cage. (They were apprehended a few days later, curled up inside a sleeping bag in my closet.)

Despite such hazards, I soon grew to love the place: It was wild—a desert wedged between tall purple mountains on one side and thousands of miles of feral ocean on the other. The waters were warm, and caravans of gray whales used the coast as their seasonal freeway between Alaska and their calving coves to the south. Thanks to an underground oasis, parts of the valley looked as green and fertile as any Indonesian rice field. There also happened to be a world-class point break, completely unknown except to a handful of surfers. Usually when I stumble across a perfect gypset enclave, someone else has gotten there first. But in the case of Todos Santos, that someone was me.

Days were spent swimming, sunbathing, and chugging cans of warm Tecate beer and flirting with Mexican boys. On Saturday nights we would do our best to imitate formal Catholic style and join the local families at the *mutualista* building, for the town dance in a cement courtyard. A live ranchero band

Opposite: Socialite of the galaxy Euva Anderson outside her boutique, Mixtica.
Following pages: Angie Young and Toby Kline after a day of surfing.

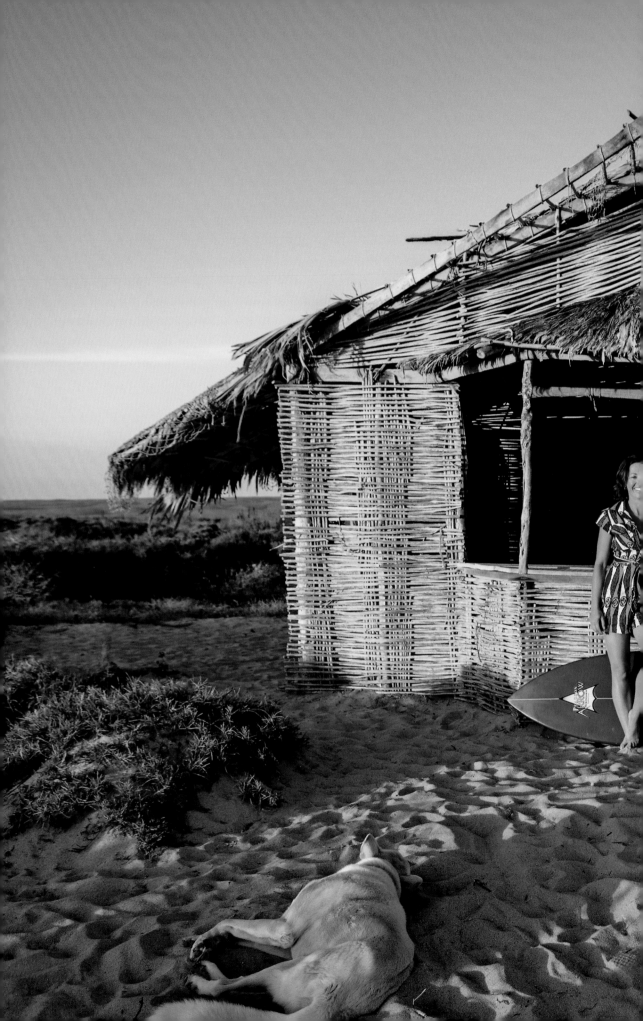

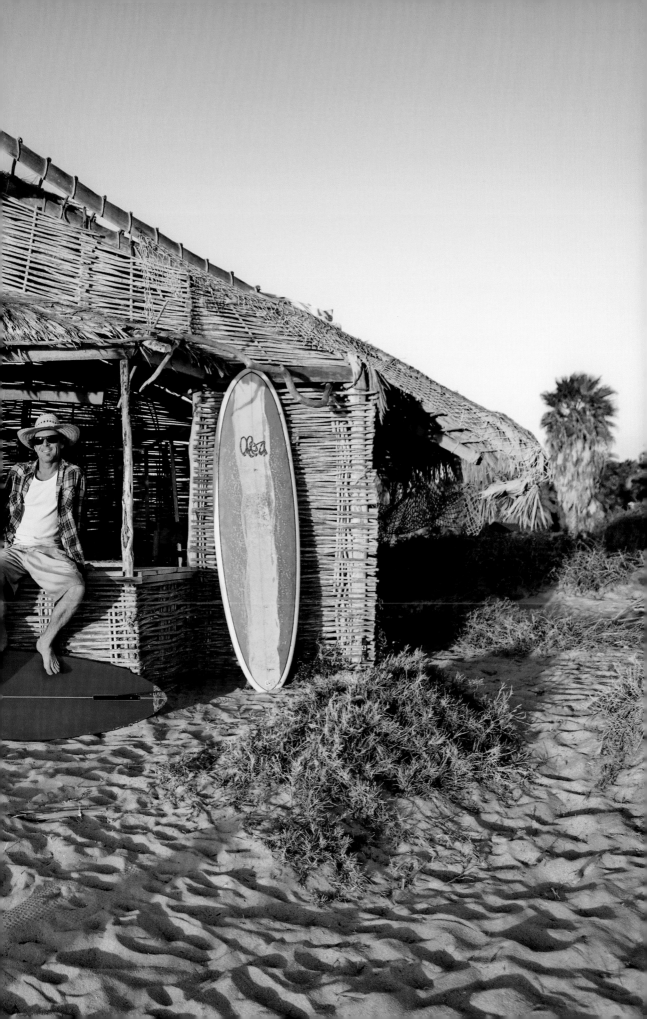

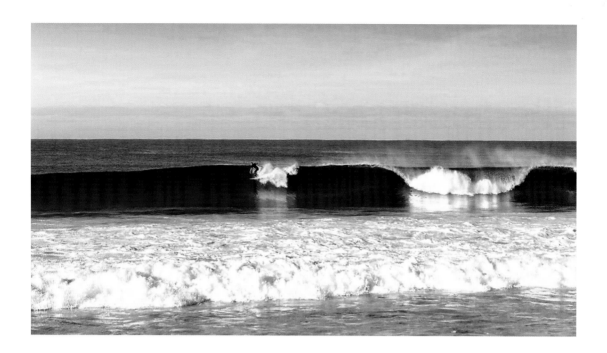

played, and men in crisp cowboy hats would ask my father's permission to dance with us. They'd twirl us around to the beat, as fast and bumpy as a horse's gallop, and afterward we'd fall into the plastic chairs dizzy and giggling.

Todos Santos was founded by the Jesuits as a mission town in the 1700s, and it prospered from the sugar cane industry in the nineteenth century. But by the time we arrived, it was just a small, dusty village. The sole lodging, the Hotel California—rumored to be the inspiration for the Eagle's classic song (until Don Henley publicly stated it wasn't)—was long since abandoned. There was only one restaurant, and only one other family of gringos in town. My father was so taken with the place that he, along with his Hollywood friends, decided to buy an abandoned sugar warehouse covered in graffiti and cobwebs. Castilla de Dracula was what the locals called it because of its imposing brick architecture and pointy gothic windows, and the fact that it was haunted. They bought it for a few thousand dollars.

To us, Castilla de Dracula was a disorganized vacation commune. We cooked on a two-burner gas camping stove, slept in a big dorm-style room on cots that had to be checked for scorpions every night, and threw fantastic parties. Paradise? Perhaps in retrospect it was.

Slowly word about Todos Santos spread, and the town became a haven for film people hiding from the scene in Los Angeles, artists and writers escaping New York City winters, and, for some reason, a lot of French. We were sad when the treacherous road from Cabo San Lucas to Todos Santos was straightened and paved into a highway, making the town too accessible to airports and the uncommitted. But we were happy for the company—or some of it, anyway. Almost anyone who electively spent time in Todos Santos possessed a certain eccentric streak. You needed it to see the esoteric beauty of Mexican village life through the dust that weighed down our hair and permeated our clothes.

Above: A secret surf break near town. *Opposite:* Miguel mixing cocktails at his "*famoso*" restaurant, Miguel's Chile Relleno.

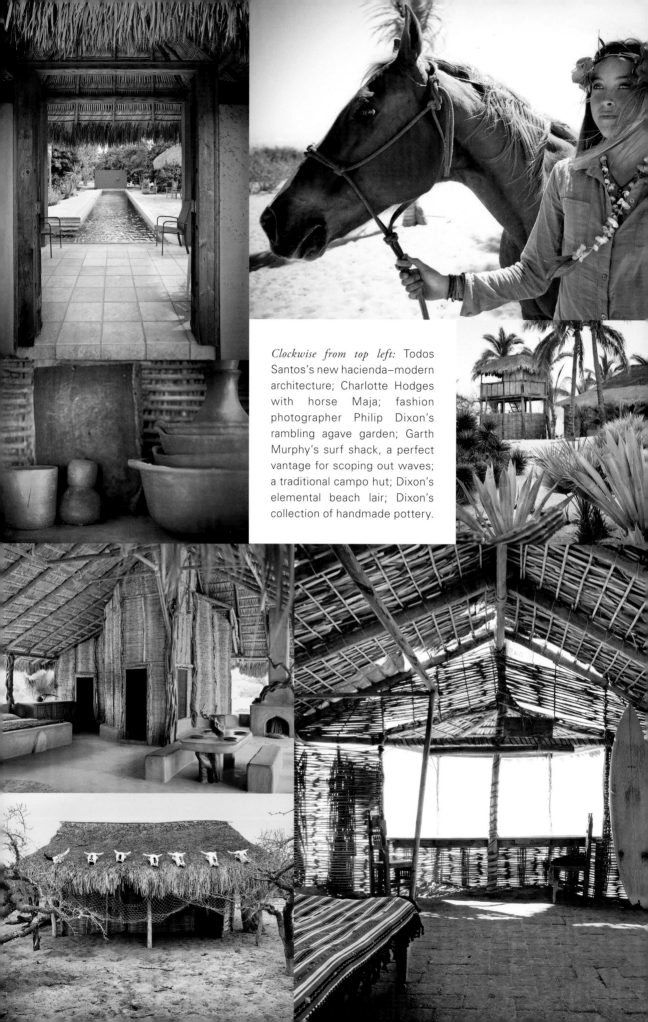

Clockwise from top left: Todos Santos's new hacienda–modern architecture; Charlotte Hodges with horse Maja; fashion photographer Philip Dixon's rambling agave garden; Garth Murphy's surf shack, a perfect vantage for scoping out waves; a traditional campo hut; Dixon's elemental beach lair; Dixon's collection of handmade pottery.

Todos Santos was, and still is, a town possessed by a palpable mystical undercurrent. It has more than its share of shamans and *brujas* (witches), not to mention surf bums with questionable pasts and other pseudo-outlaws. (This is true of other gypset-type Mexican towns, including Sayulita, Tulum, Troncones, and Tepoztlán. The promise of an offbeat, unfettered paradise is the reason social bandits like Ken Kesey and Timothy Leary have sought temporary refuge in small south-of-the-border pueblos.) Today the dirt streets of Todos Santos have been swept clean, and the place is hardly a secret. In the mango and palm groves on the outskirts of town, garish gringo dream villas have been popping up like mushrooms after a rain. But it's still a village, small enough that if you need to find someone, you just show up for dinner at Café Santa Fe, a restaurant in an airy colonial building on the main plaza. In the evening everyone is at long wooden tables sharing plates of lobster ravioli, yellowtail carpaccio, and margaritas mixed with Damiana, a local herb liqueur, that are worth flying in for.

Over the decades Todos Santos has attracted an expat crowd inspired, at least a little bit, by the ragtag glamour of Castilla de Dracula. Eric Engler, a Los Angeles cinematographer, and Catherine Chambaret, his stylist wife from Paris, created an eco-compound before eco was cool: two small adobe cottages surrounded by vegetable patches and a micro-farm with lambs, chickens, and cows. Catherine, who parades around in her trademark turban and pointy red sunglasses, orchestrates Versailles-meets-campo dinner parties featuring spit-roasted lamb, with guests who seem to be airlifted in from gypset central casting: espadrille-clad photographers, movie directors, and fashion stylists with foreign accents, lithe lovers, and beautiful children.

Philip Dixon, a fashion photographer from Venice Beach, is easy to spot. He walks around barefoot in linen pajamas looking like a Buddhist Lord Byron by way of Antwerp. In an agave garden just north of town, Dixon built a sublime rustic-minimal retreat: just one big room under a palm-thatch roof with a concrete floor sculpted into a giant daybed. On the side facing the Pacific Ocean, there are no walls. Everything is monochrome, earthy, and handmade—from the chunky pre-Colombian plates to the knobs on the stove. It's John Lautner gone ranchero.

Garth and Euva, a legendary Todos Santos couple, bought a ranch near one of the best-breaking waves in all of Mexico. Euva, a former model, is a bohemian socialite-of-the-world from Guatemala and Switzerland and places beyond. Garth is a surfer who grew up in Hawaii and later moved to Southern California, and hung out with the famed Windansea crew chronicled by Tom Wolfe in *The Pump House Gang* (1968). Garth and Euva's ranch is always a wild ride, with elegant horses roaming loose outside the baroque stables, part of which have been converted into Euva's painting studio. Wayward friends are constantly stopping by—a gang of traveling performers from Portland, for instance, pedaled there on bicycles. Garth—a renaissance waterman who's not only an expert surfer but also a singer-songwriter,

Following pages: Downtown Todos Santos. *Page 162:* Dining at a local café.

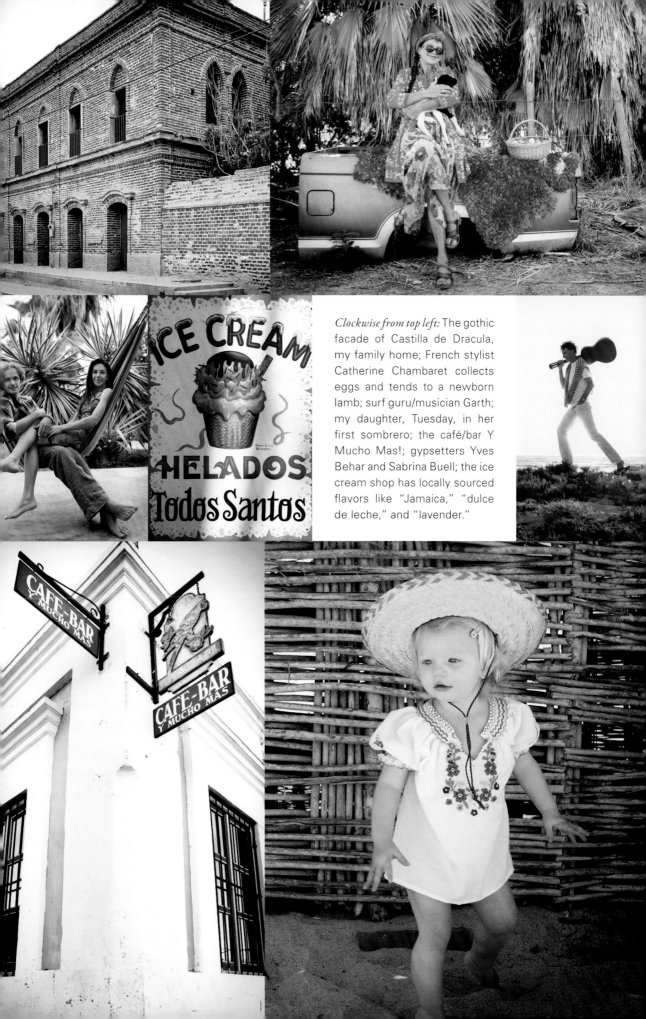

Clockwise from top left: The gothic facade of Castilla de Dracula, my family home; French stylist Catherine Chambaret collects eggs and tends to a newborn lamb; surf guru/musician Garth; my daughter, Tuesday, in her first sombrero; the café/bar Y Mucho Mas!; gypsetters Yves Behar and Sabrina Buell; the ice cream shop has locally sourced flavors like "Jamaica," "dulce de leche," and "lavender."

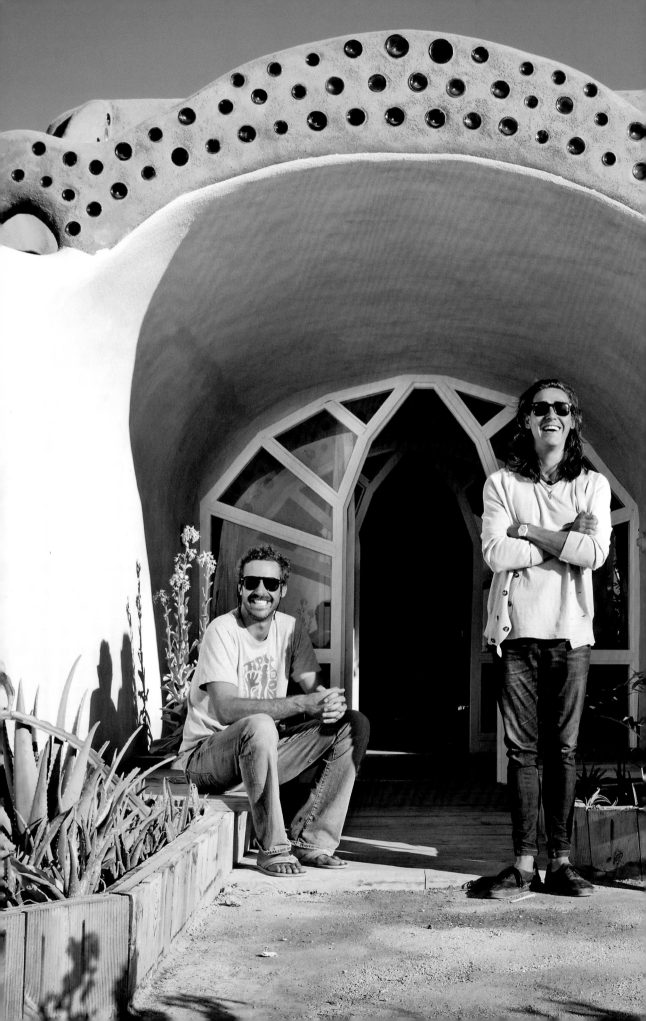

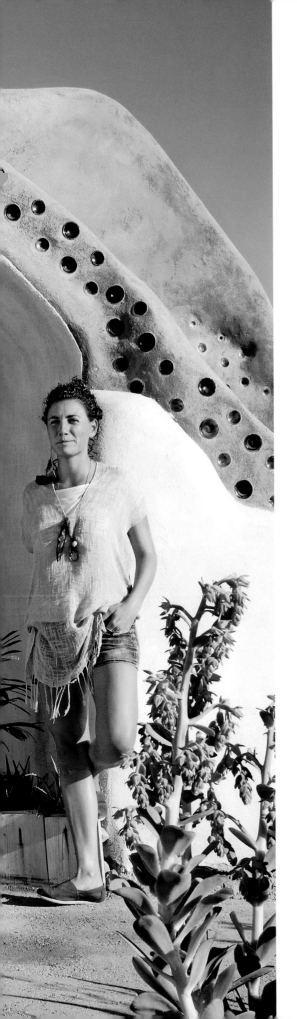

novelist, and conservationist—is constantly monitoring the waves from a *palo de arco* shack on the beach. He often has a cell phone glued to his ear to alert friends up and down the coast—like surf royalty Mike Doyle and Pat Curren—of approaching swells.

One afternoon a few years ago, Garth offered to teach me to surf. Even though I spent every winter of my teenage life on the beach in Todos Santos, I never dared to paddle out. The waves often reach to a crushing double overhead, and gnarly wipeouts seemed best witnessed from the safety of shore. But there was something about Garth, reassuring and guru-like, that convinced me to go out, and of course my life changed forever. Now, like my father before me, I'm willing to travel thousands of miles on just the rumor of a perfect, uncrowded break. There must also be a town or village nearby with a groovy après-surf scene; that's the definition of gypset.

What I love about surfing is the challenge of finding that perfect wave others don't notice, or are too lazy to get to until after you're happily barreling down its face. This same philosophy can be applied to life, and in particular, to traveling. Finding the "perfect" place requires ferreting out potential when it's just a blip on the horizon and then making it come true. Sort of like Todos Santos.

The Earthship, an experimental eco-house, built by some surfers from Mexico City. Friends contributed old bottles, cans, and tires for the construction (From left: Santiago Gaxiola, Pablo Ulibarri, and Anna Sorrentino).

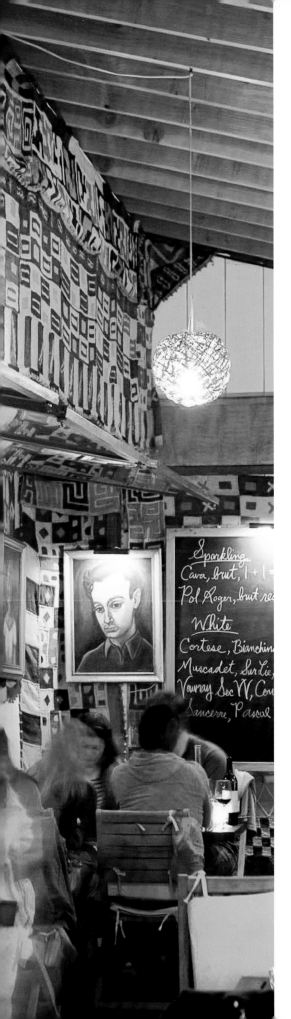

ADDRESS DIRECTORY

MONTAUK, USA

THE CROW'S NEST INN AND RESTAURANT

The gypset dining hall of Montauk,
serving local produce and seafood
with beachy decor inspired by Uruguay
and Africa.

4 Old West Lake Drive
Montauk, New York 11954
Tel: 631-668-2077
Fax: 631-668-2078
www.crowsnestmtk.com

RUSCHMEYER'S

A mid-century restaurant and motel
converted into a summer wonderland;
long picnic tables, lots of rosé, and a lawn
with tepees and badminton.

161 Second House Road
Montauk, New York 11954
Tel: 631-668-2877
www.kingandgrove.com/Montauk-Hotels/
Ruschmeyers

WEST COUNTRY, ENGLAND

BOTELET FARM

A family-run farm that rents out cottages,
rooms, yurts, and a gypsy caravan with a
bling, mirrored interior.

Botelet Farm
Herodsfoot, Liskeard
Cornwall PL14 4RD, England
Tel: + 44 (0) 1503-220-225
www.botelet.com

The Crow's Nest Inn and Restaurant
in Montauk.

PORT ELIOT FESTIVAL

Perry and Cathy St. Germans' "creative" festival held in July on the grounds of their ancestral home, a converted tenth-century monastery.

St. Germans
Cornwall, PL12 5ND, England
Tel: +44 (0) 1503-232-783
www.porteliotfestival.com

AEOLIAN ISLANDS, ITALY

HOTEL RAYA

A chic, rambling hotel built into a hillside that incorporates existing boulders, caves, and views of the erupting volcano on the neighboring isle of Stromboli.

Via San Pietro, 75
98050, Panarea, Italy
Tel: +39 090-983013
Fax: +39 090-983103
www.hotelraya.it

LA SIRENA

The art crowd favors the terrace of this traditional seafood trattoria in the tiny seaside village of Pecorino. Standouts include squid ink pasta and swordfish carpaccio.

Via Pecorini Mare
98050 Filicudi, Italy
Tel: +39 090-9889997
Fax: +39 090-9889207
www.pensionelasirena.it

DEIÀ, SPAIN

CAFÉ SA FONDA

A small, nondescript bar in the center of town that's the epicenter of the island's decadent social scene.

Ask in town for directions.

HOSTAL VILLA VERDE

For those on a semi-limited budget, the next best thing to being a houseguest is a room at this grandly proportioned villa.

Calle Ramon Llull, 19
017179, Deià, Majorca, Spain
Tel: +34 971-639037
Fax: +34 971-639485
www.hostalvillaverde.com

LAMU, KENYA

PEPONI HOTEL

A classic, colonial-style hotel where eccentrics gather for cocktails on the harbor side terrace. It features one of the only bars on this Muslim island.

P.O. Box 24
80500 Lamu, Kenya
Tel: +254 (0)20-802-3655
www.peponi-lamu.com

AMAN BOUTIQUE

The place to stock up on exotic wearables such as pink flamingo trimmed scarves and embroidered caftans.

Down a lane in Shela.
Ask locals for directions.

NORTH GOA, INDIA

In North Goa there's a hotel for every mood. Elsewhere is an exclusive, wild property on the ocean with traditional Portuguese cottages and luxury tents best for retreat and relaxation. For party hunters, there's Sur La Mer, an airy villa centered around a swimming pool courtyard. And for a stylish but no-frills experience, Yab Yum has little coconut-looking huts by the beach.

ELSEWHERE

The address is a secret.
Phone calls are discouraged. But you can book/email on www.aseascape.com.

SUR LA MER

Morjim-Ashwem Road
Morjim, Pernem Taluka, Goa, India
Tel: +91-832-6453102
Fax: +91-832-2244999
www.surlamergoa.com

YAB YUM

Ashwem Beach
Mandrem, Pernem, North Goa,
India 403527
www.yabyumresorts.com

BYRON BAY, AUSTRALIA

SPELL AND THE GYPSY COLLECTIVE BOUTIQUE

A homegrown Byron label that has perfected the boho-beach nymph look; feather headdresses, peasant minis, Native American print T-shirts, and chunky jewelry.

13 Banksia Drive
Byron Bay, NSW 2481 Australia
Tel: +61 (0) 402-180-456
www.spelldesigns.com

RAE'S ON WATEGO'S

A boho-luxe boutique hotel on Watego's beach, with a right-hand point break that's a longboarder's dream.

8 Marine Pde, Watego's Beach
Byron Bay, NSW 2481 Australia
Tel: +61 2-66-855-366
www.raes.com.au

ALTO PARAÍSO, BRAZIL

GALLERIA AGAMI

An art gallery owned by Sahar Farmanfarmaian and Cristoforo Gaetani featuring the work of Carlito Dalceggio and other collectibles from afar. The opening receptions are over-the-top affairs worth flying in for.

Avenida Valadao Filho # 672
Alto Paraíso de Goiás, GO
Chapada dos Veadeiros, Brazil
Tel: +55 62-3446-1996

YOGASTRAL

You'll feel extra soulful taking yoga classes in a funky blue dome with the limber, worldly instructors, Laurent Dauzou, from Paris, and Amber Joy Rava, an American performance artist.

Rua Joaquim da Costa, 320
Alto Paraíso de Goiás, GO
Chapada dos Veadeiros, Brazil
Tel: + 55 62-3446-1665
www.yogastral.org

JOSÉ IGNACIO/CABO POLONIO, URUGUAY

LA HUELLA

The quintessential gypset hangout. You can meet the whole town while sitting at the bamboo bar. The *a la parrilla* (grill)–based menu is down-home Uruguayan.

Playa Brava
José Ignacio, Maldonado, Uruguay
Tel: +598-4486-2279
www.paradorlahuella.com

CASA SUAYA

A contemporary design hotel with bungalows and cabanas powered by the affable owner, Adolfo Suaya, a fantastic host who always knows where the party is.

Ruta 10, km 185.5
José Ignacio, Uruguay
Tel: +598-4486-2750
www.casasuaya.com

TODOS SANTOS, MEXICO

CAFÉ SANTA FE

An elegant restaurant in an 1850s adobe building on the town square serving up Northern Italian-meets-the-Pacific Ocean fare, such as lobster ravioli and yellow tail carpaccio.

Calle Centenario. 4
Todos Santos, Baja California Sur
Mexico 23305
Tel: +52 612-145-0340

HOTELITO

A cheerful Luis Barragan modern boutique hotel set back from the center of town amongst sleepy palms, bougainvillea, and cacti.

Rancho de la Cachora
Todos Santos, Baja California Sur
Mexico 23305
Tel: +52 612-145-0099
www.thehotelito.com

ACKNOWLEDGMENTS

The author wishes to thank the following people for their contributions to the book:

On location: Montauk: Sean and Rachelle MacPherson; Cynthia Rowley and Bill Powers; Robin Standefer and Stephen Alesch; Rogan Gregory; Bethany Mayer; Ben Pundole; and Shelby Meade. The West Country: Perry and Cathy St. Germans; Helen Gilchrist; Kathryn Tyler; and Guy Kennaway. Deià: Alexandre de Betak; Balthazar Klarwein; and Oro del Negro. Ibiza: World Family Ibiza. The Aeolian Islands: Myriam Beltrami; Alessandra Borghese; and Ramuntcho Matta. Lamu: Katy Barker and the Guillaume family. Goa: Malini Ramani; Sara Beltran; Aneel Verman; Tina Dehal; and Denzil Sequeira. Byron Bay: Elizabeth Briedis; Melody Moon; M. Jack Bee; and Dave Rastovich. José Ignacio: Adolfo Suaya; Stacy Nikkila; and Guy Zarate. Alto Paraíso: Sahar Farmanfarmaian; Amber Joy Rava; Laurent Dauzou; Sean Souza; Eran, his mom, and the shamans. Todos Santos: Garth Murphy and Euva Anderson; Oliver Wilson; Yves Behar and Sabrina Buell; Eric McDougall and Claudia Ceniceros; Eric Engler and Catherine Chambaret; April Randol; Diana Chaplin; Gordon Chaplin; Page Cooper Sciotto; and Tuesday Miller.

A special shout-out to the super gypset photographers: Julien Capmeil; Sybil Steele; Brian Hodges; and Daniele Albright, who makes traveling way more fun and much better-looking. Special thanks to the Assouline team: Esther Kremer, Rebecca Stepler, Victorine Lamothe, and Martine Assouline. And to Kate Schelter, for the inspired watercolor gypset atlas. Gypset honorable mentions: Adam Fisher, for his beautiful editing; Holly Chaplin for ground support; and, of course, Jason Miller, a tireless champion of the gypset. Viva! xx Julia

The publisher wishes to thank the following people for their contributions to the book: Fredrik Andersson; Myles Ashby at Art + Commerce; Jonathan D. Benyon; Ilaria Brustia; Adam Butler; Stefano Butturini; Phil Dane at Yogamagic; Sergio Ghetti; Hotel Raya; Sylvie Lebrun; Jeff Moerchen; Eddie Newton; Zora O'Neill; Anne Porto at Corbis.com; Ken Regan; Justin Rose at Trunk Archive; Peter Robinson at the Museum of British Surfing; Jason Schmidt; Virginia Shannon; and Anna Vitalia.

PHOTO CREDITS